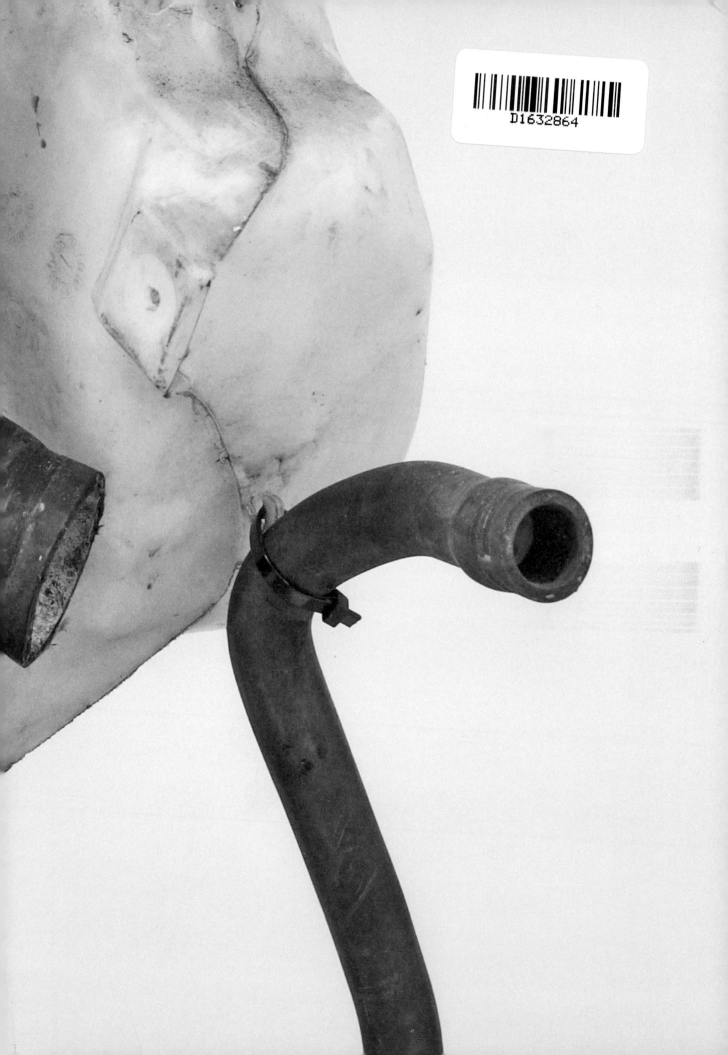

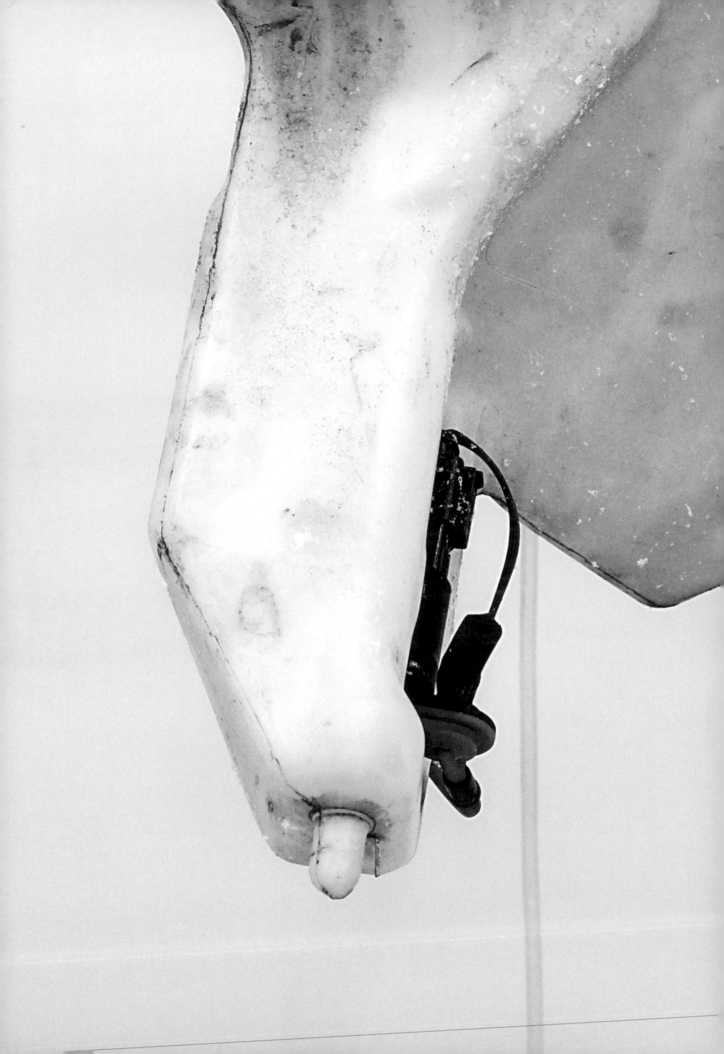

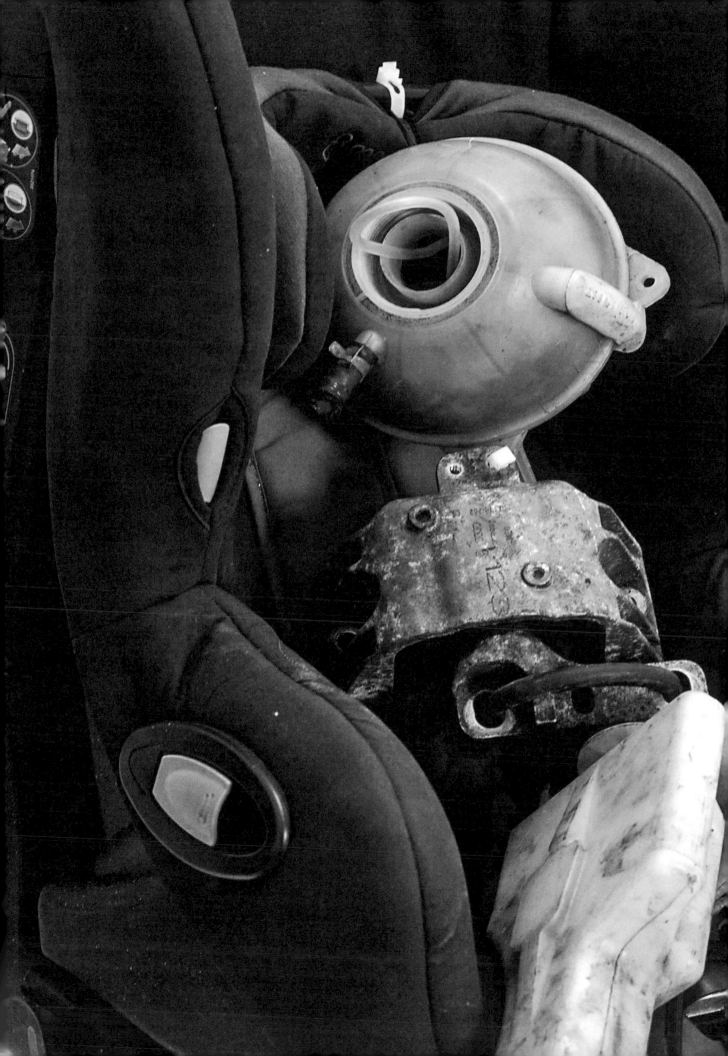

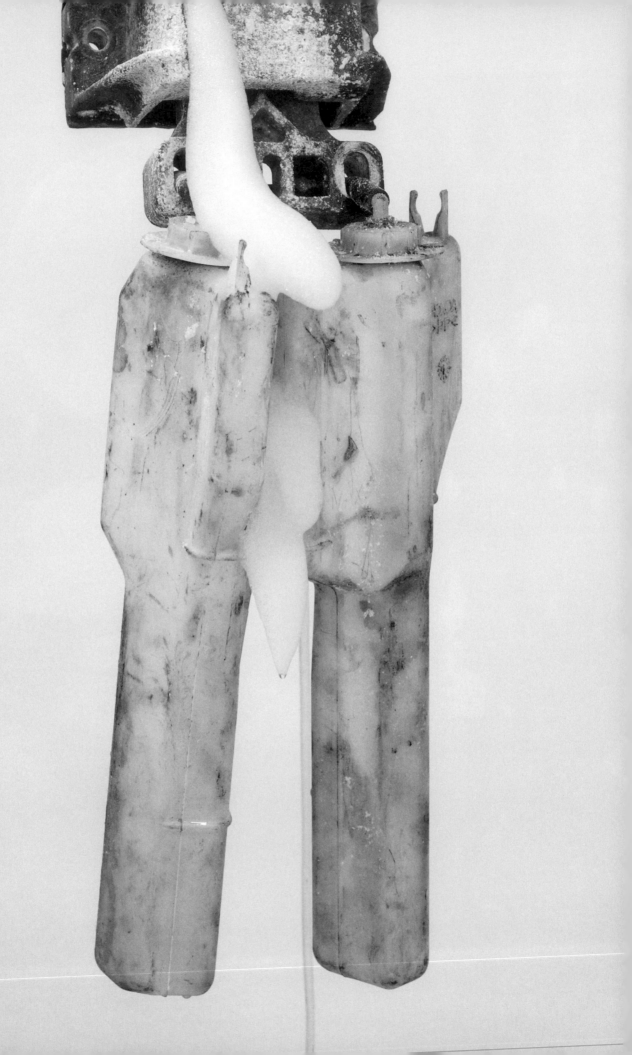

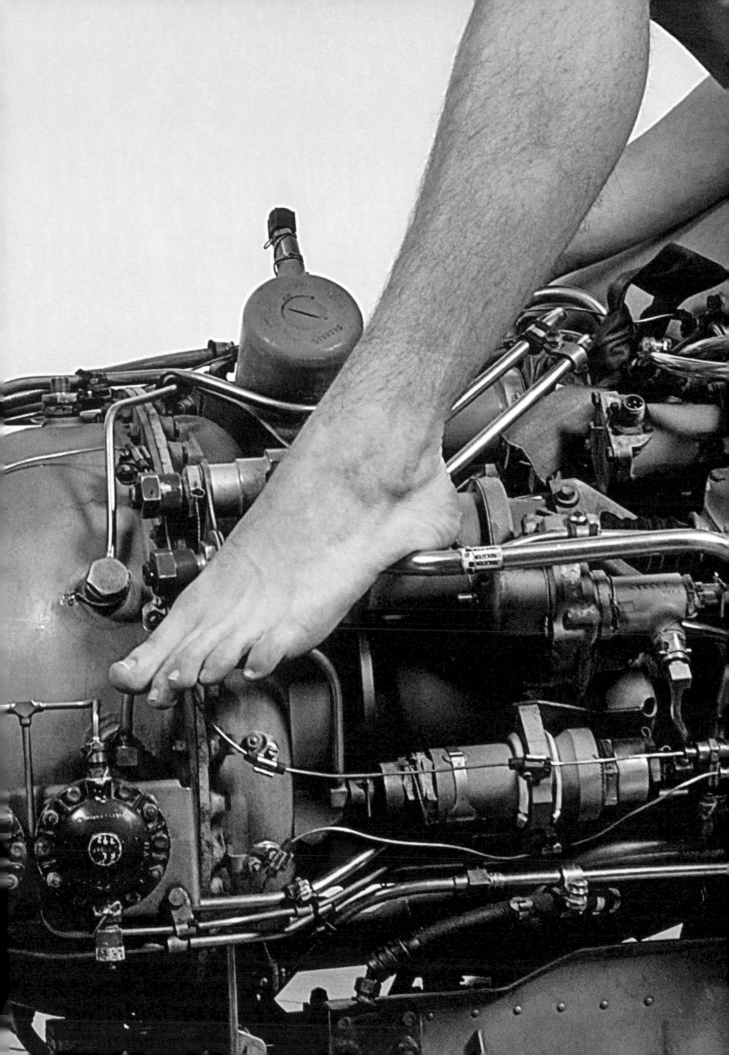

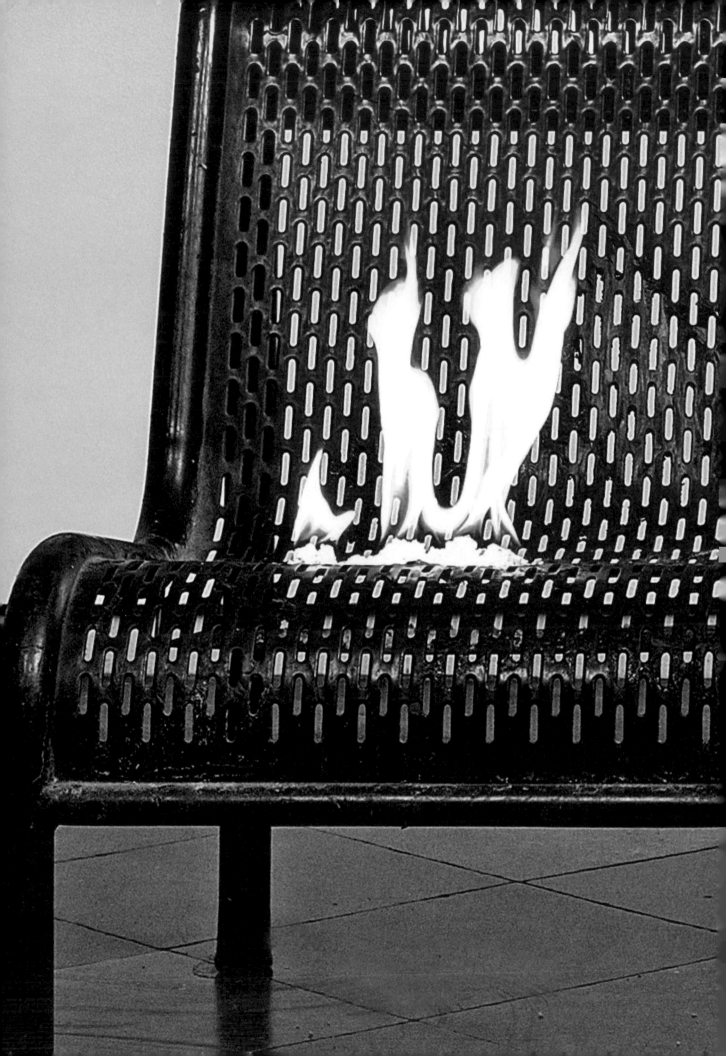

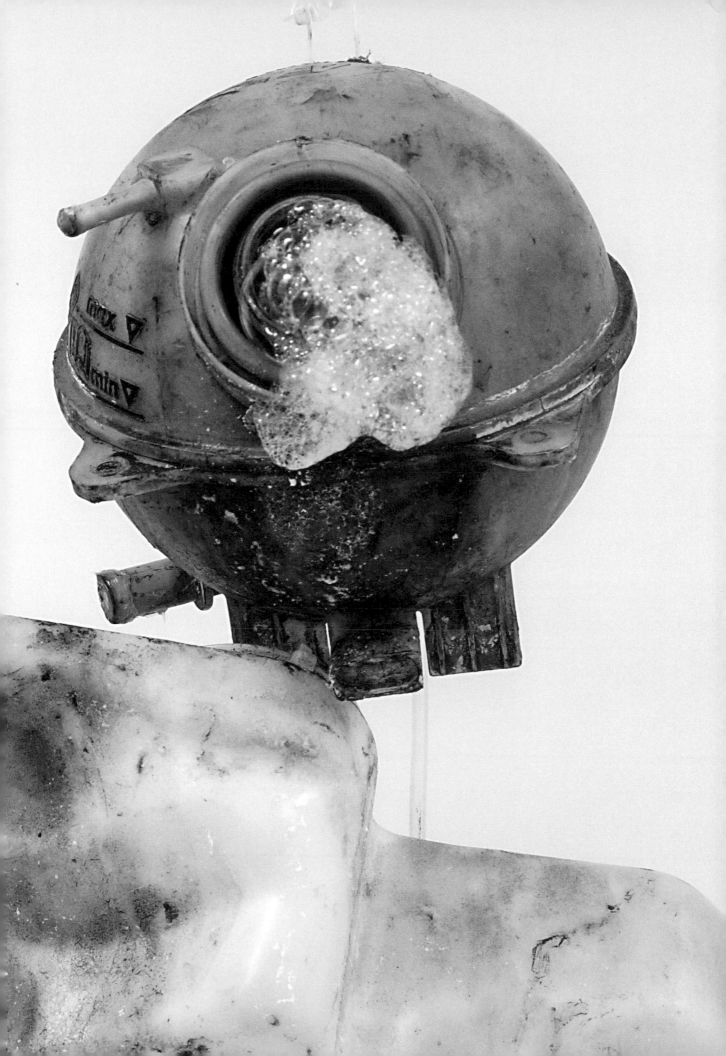

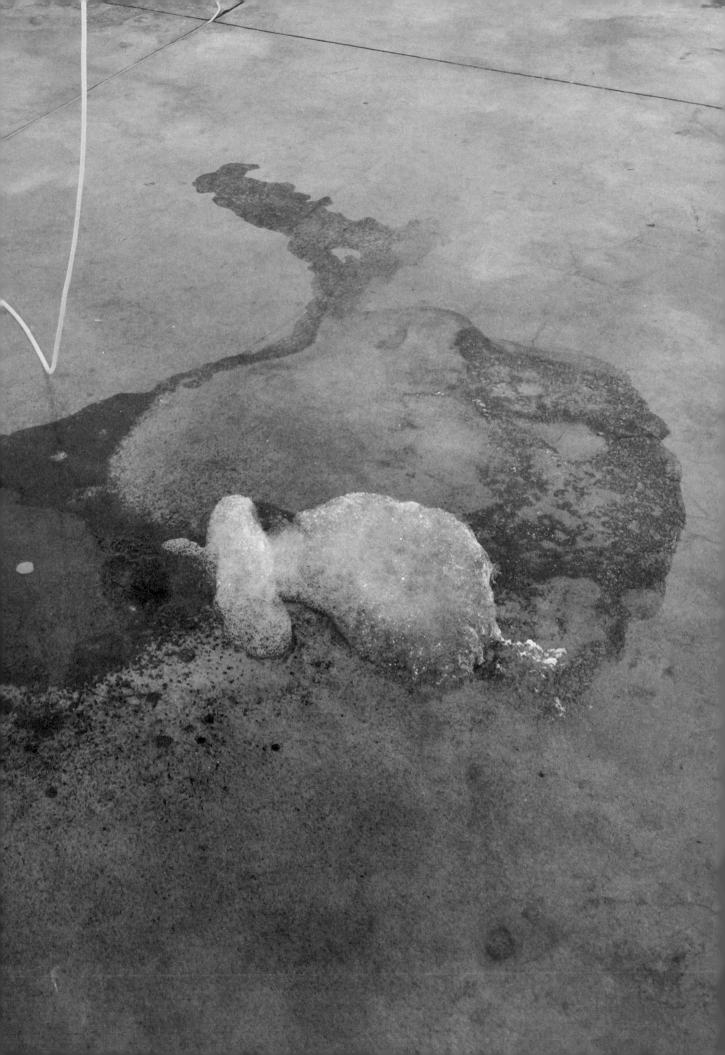

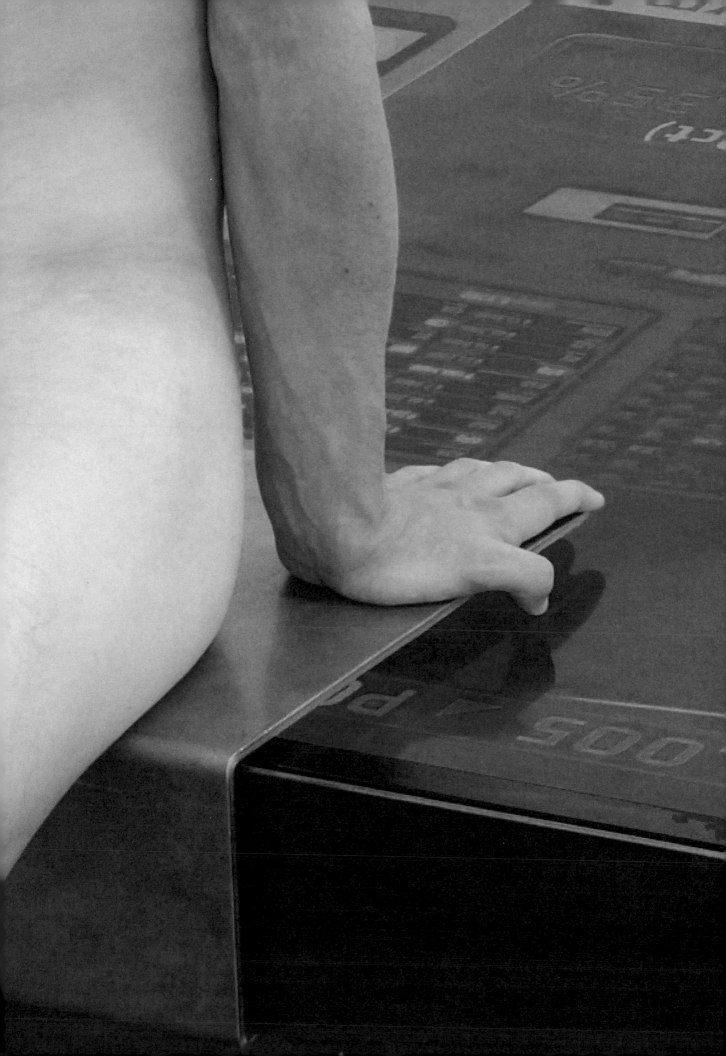

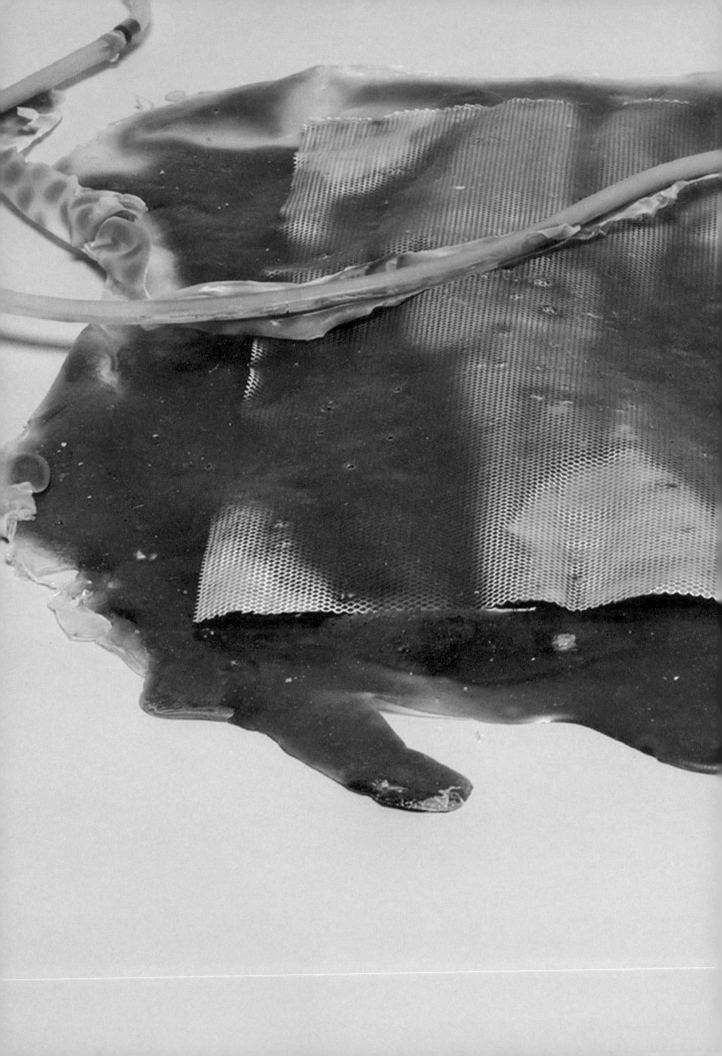

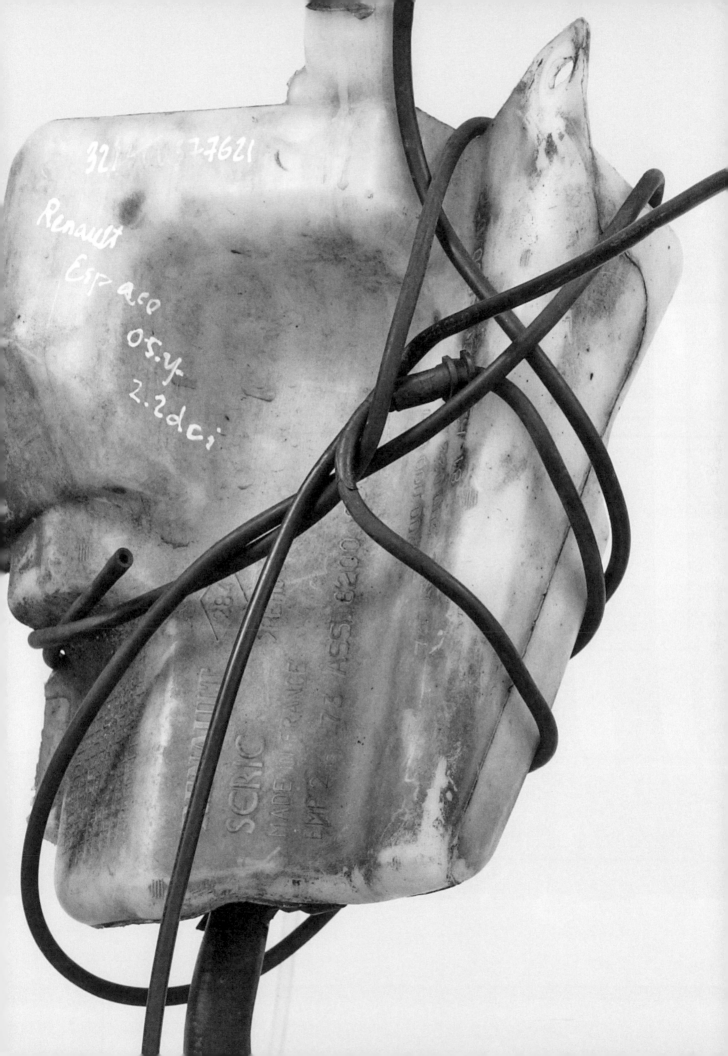

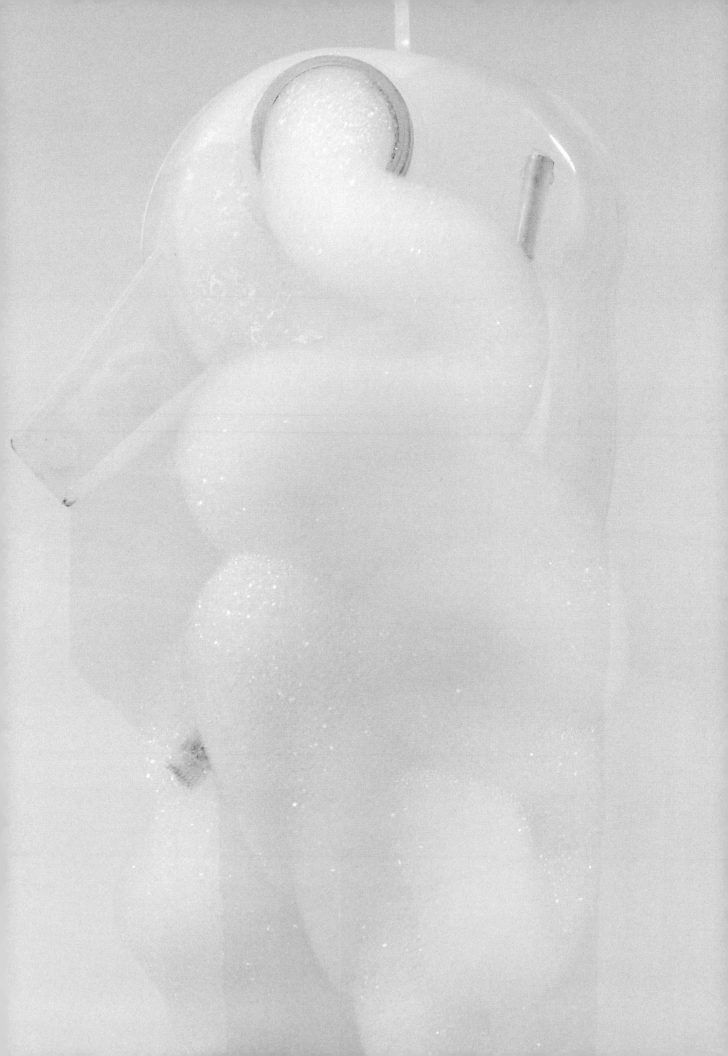

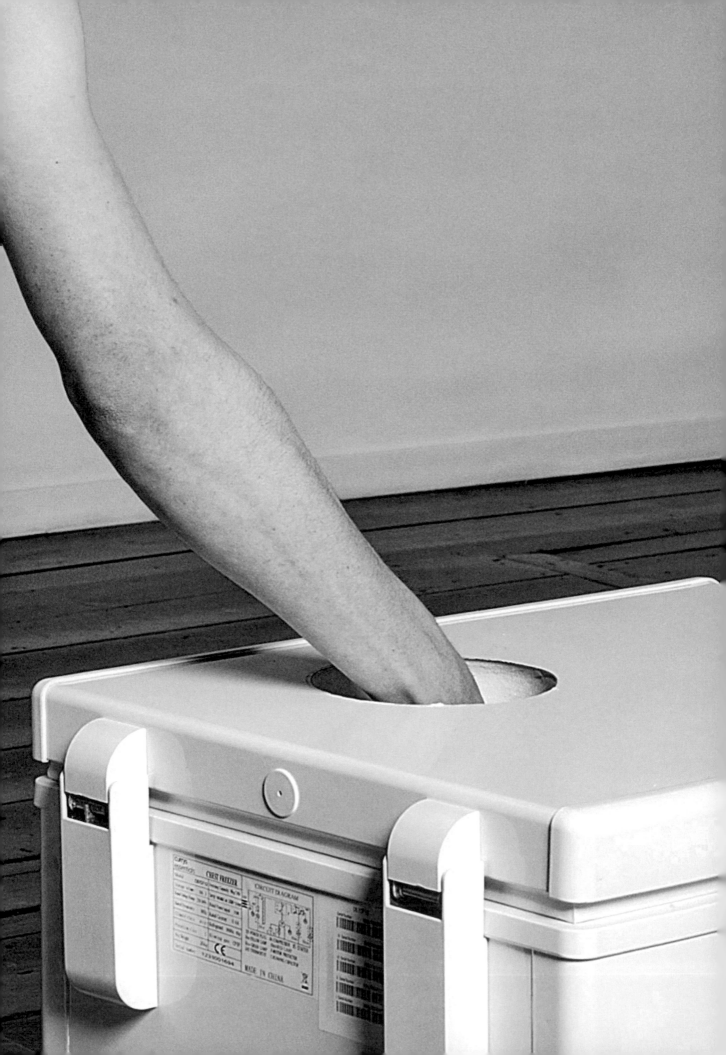

ROGER HIORNS

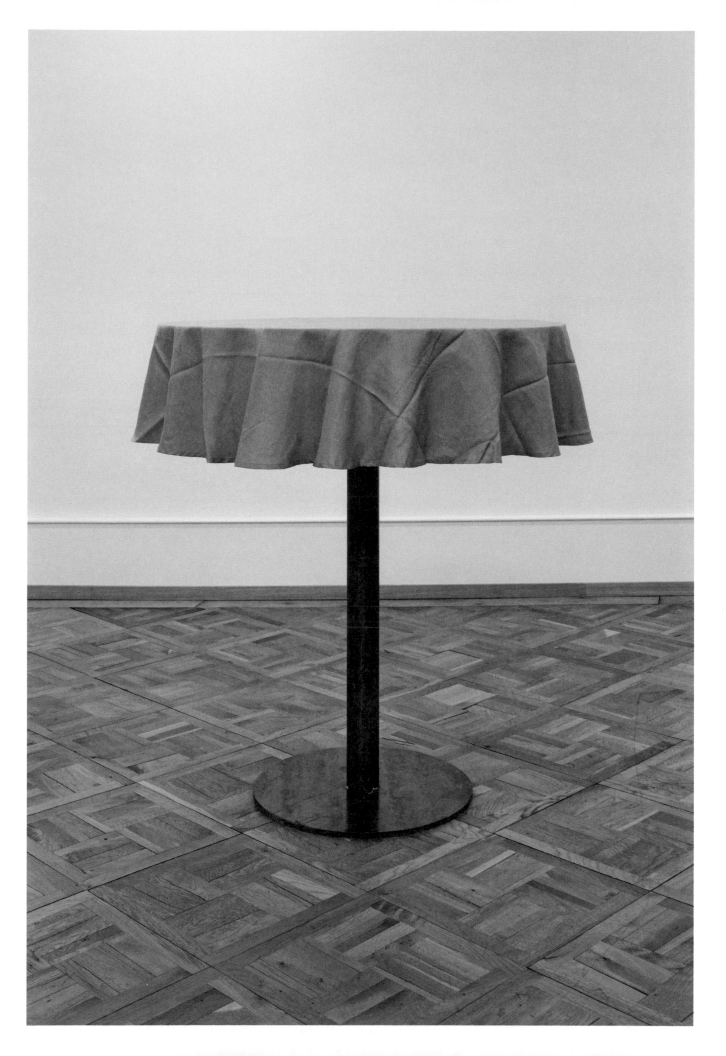

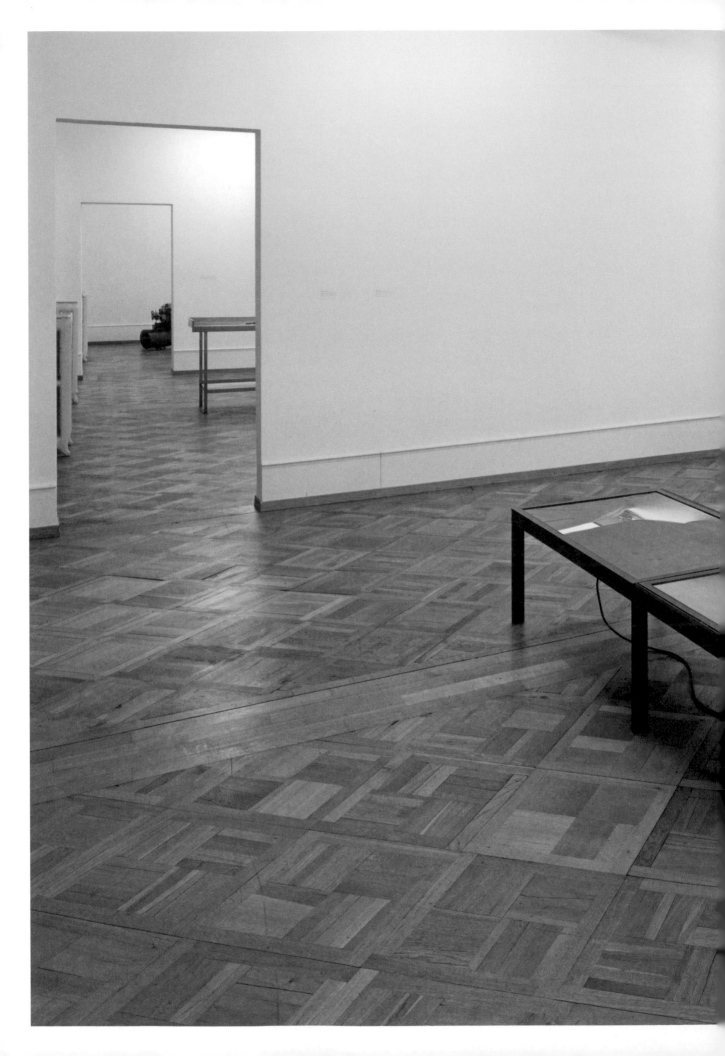

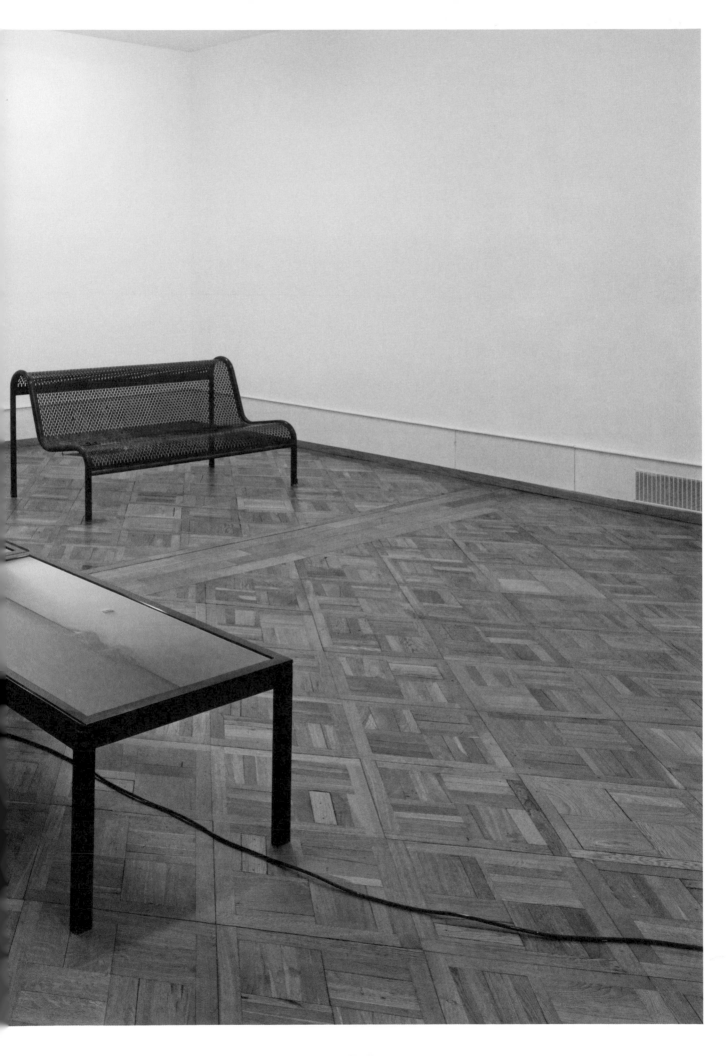

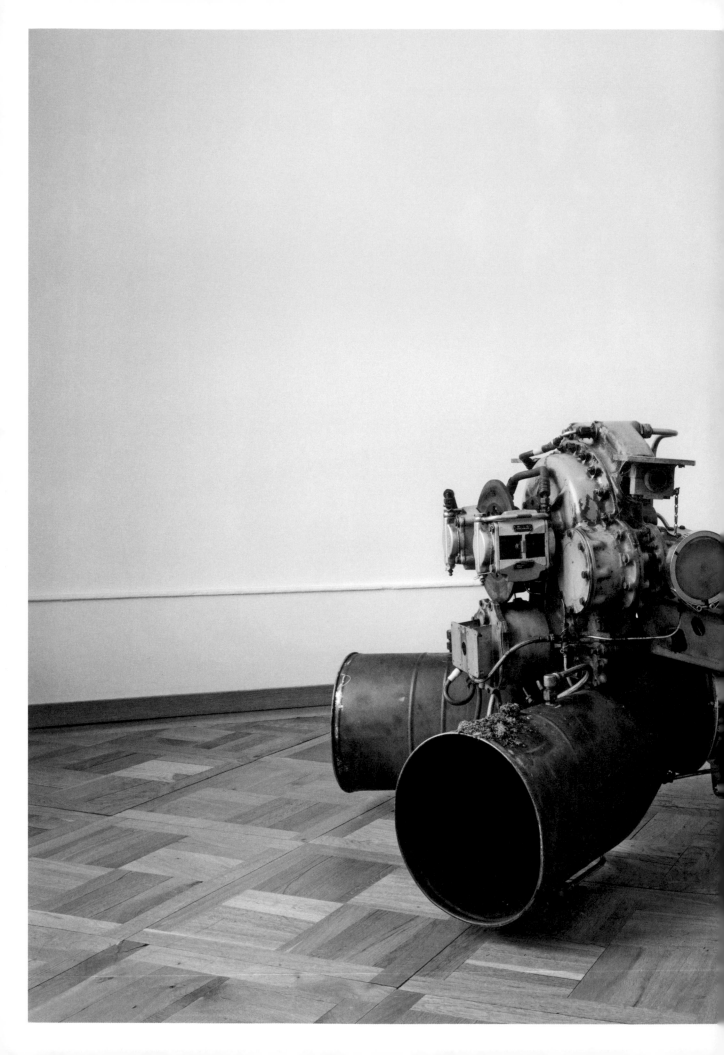

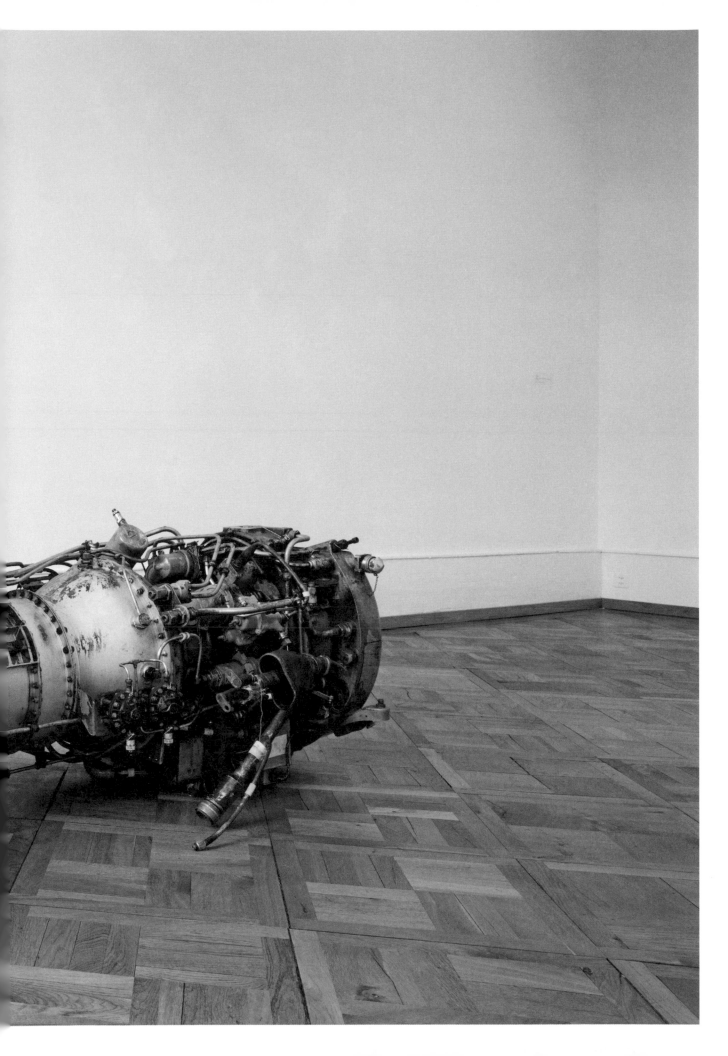

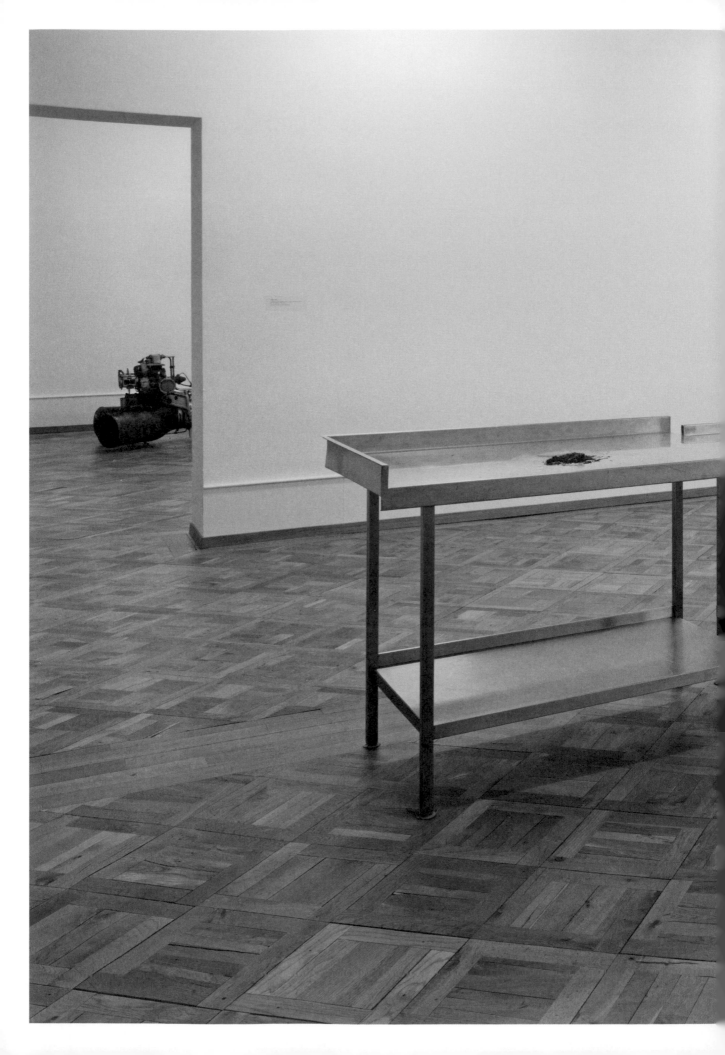

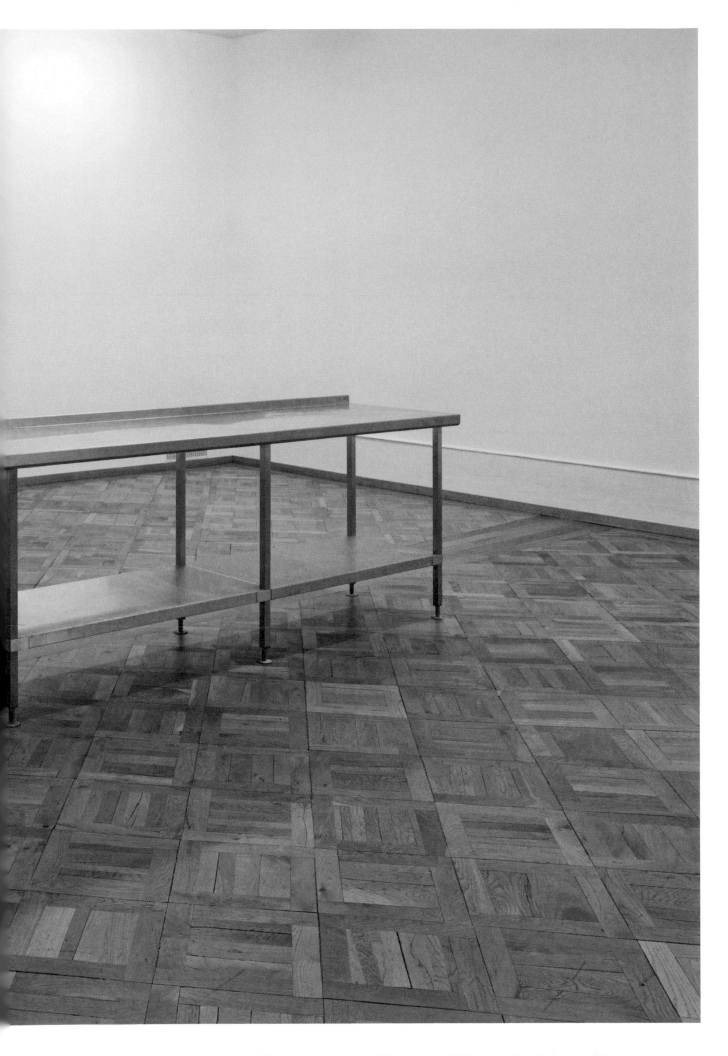

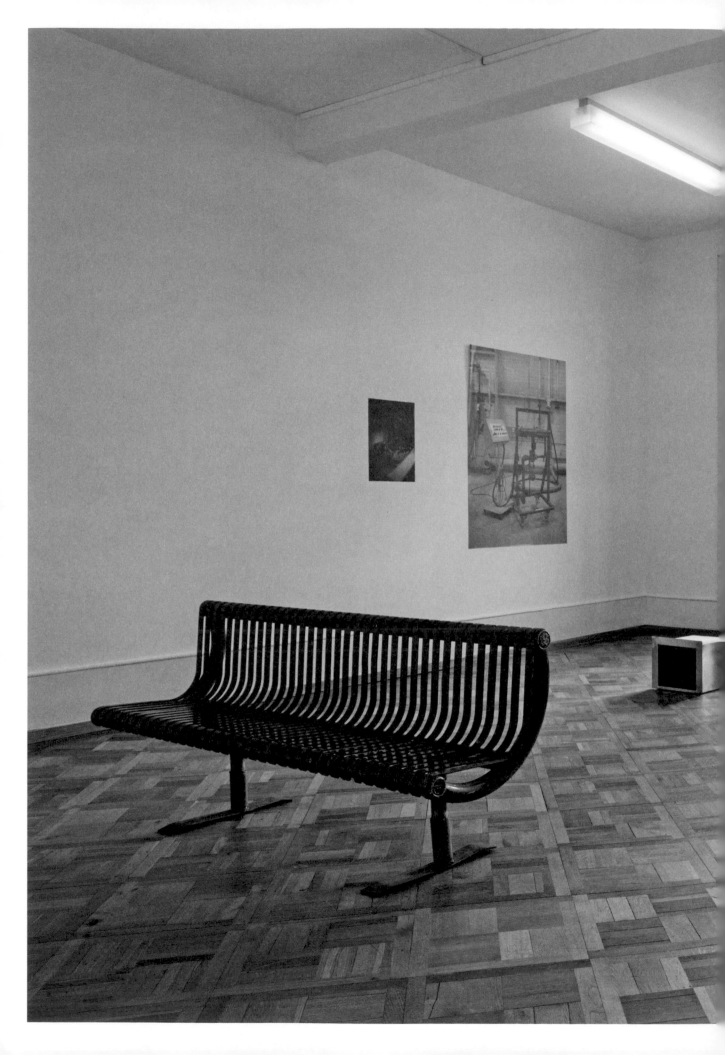

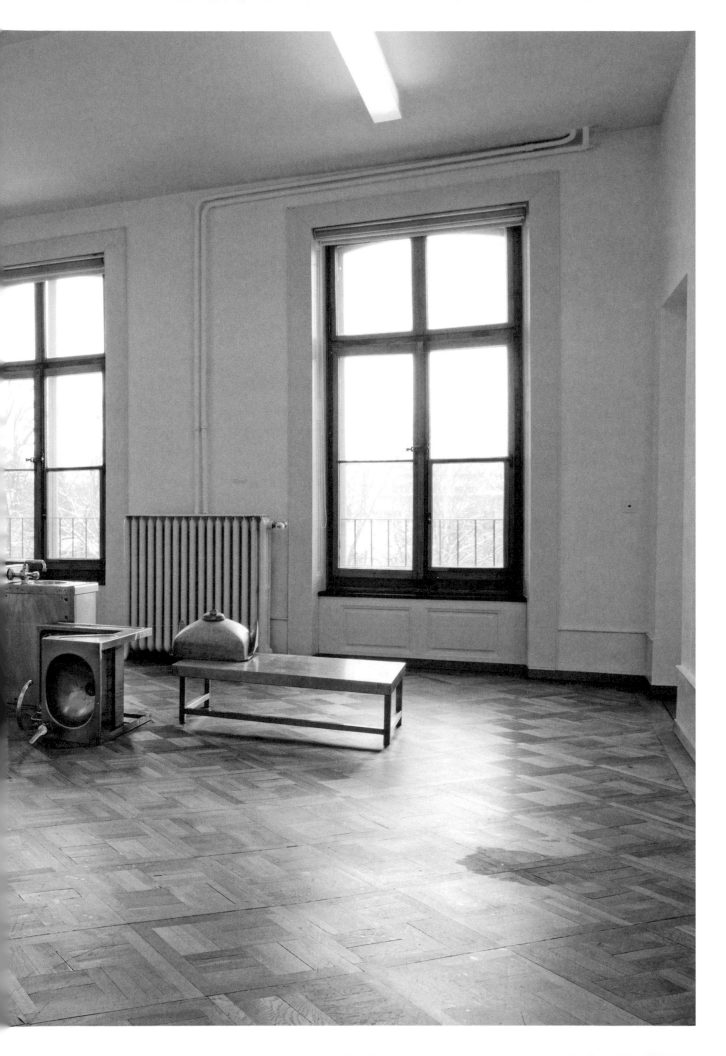

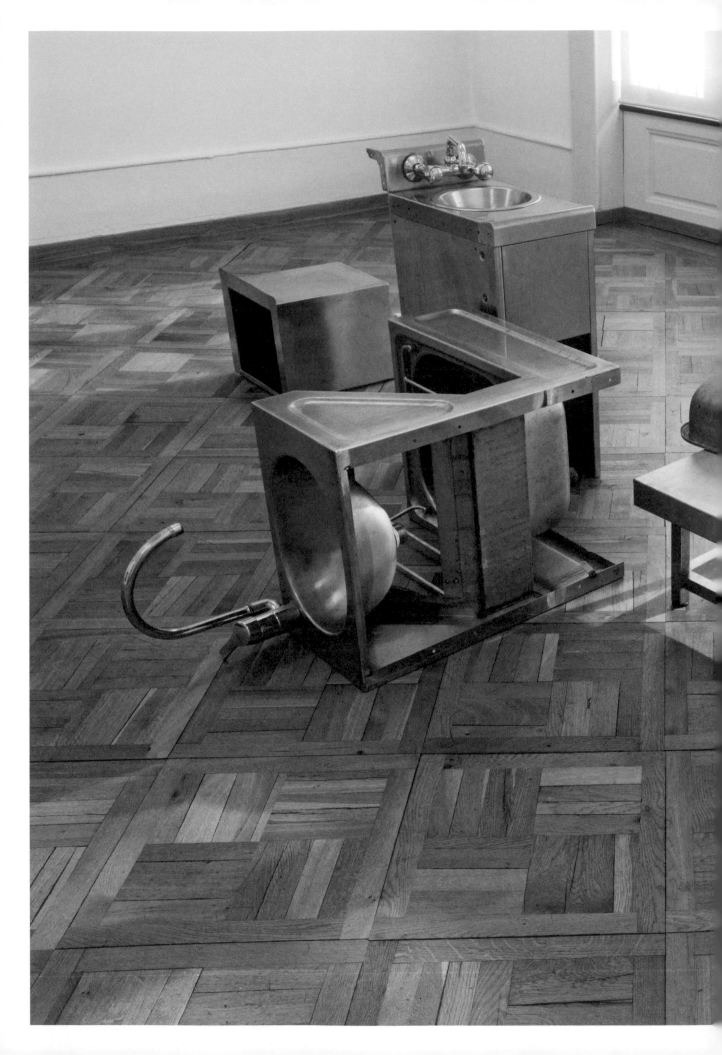

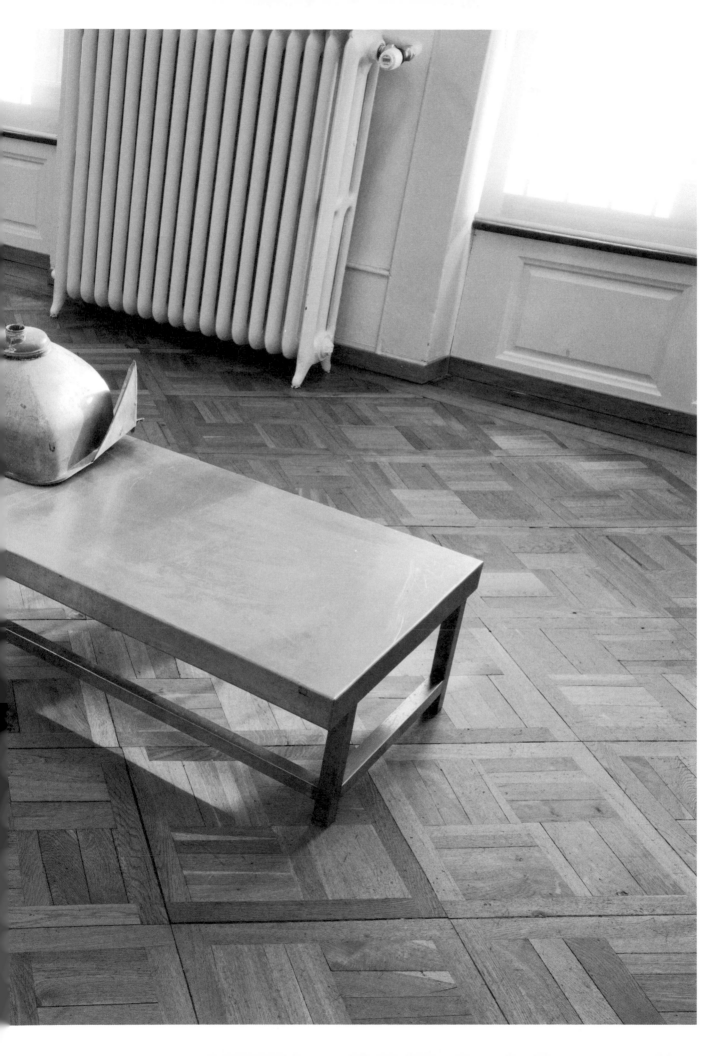

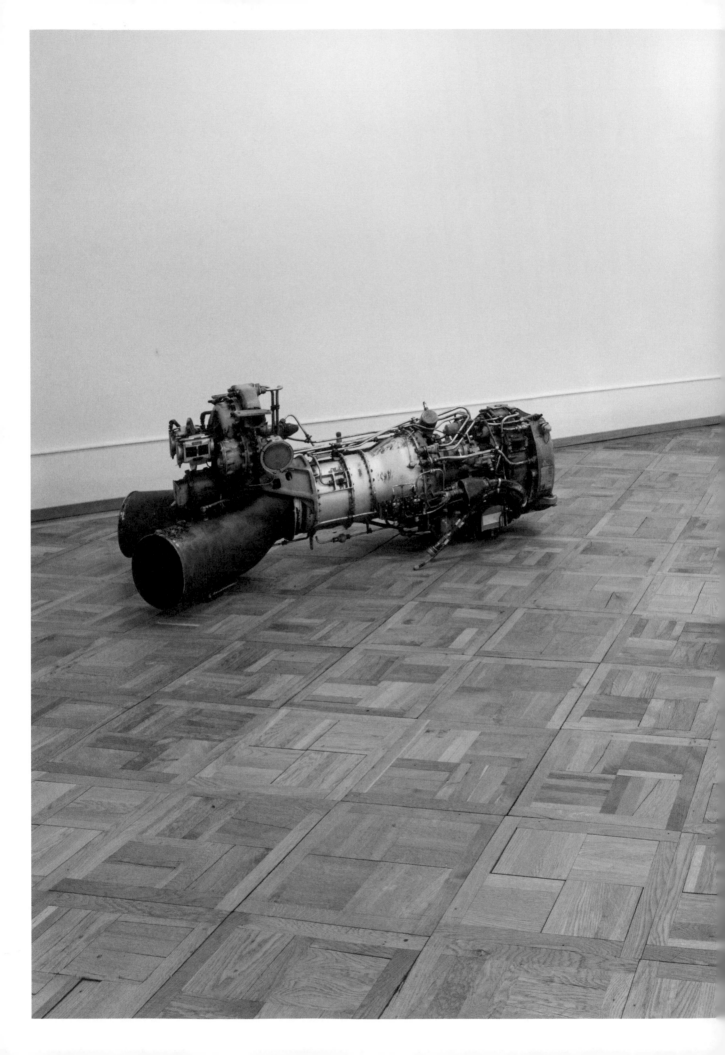

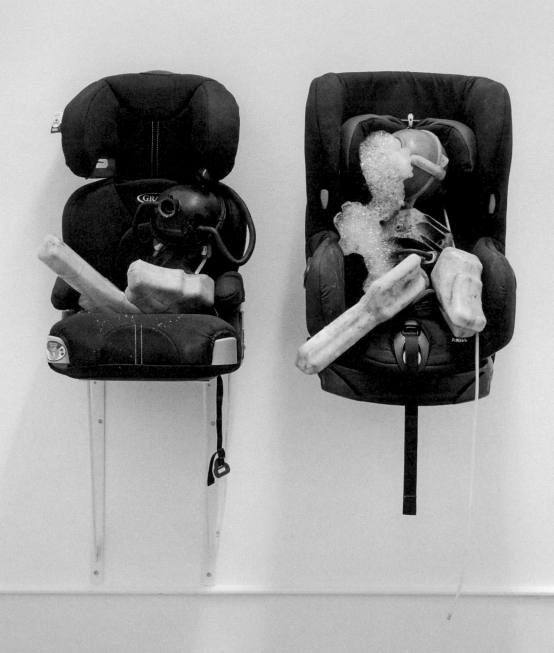

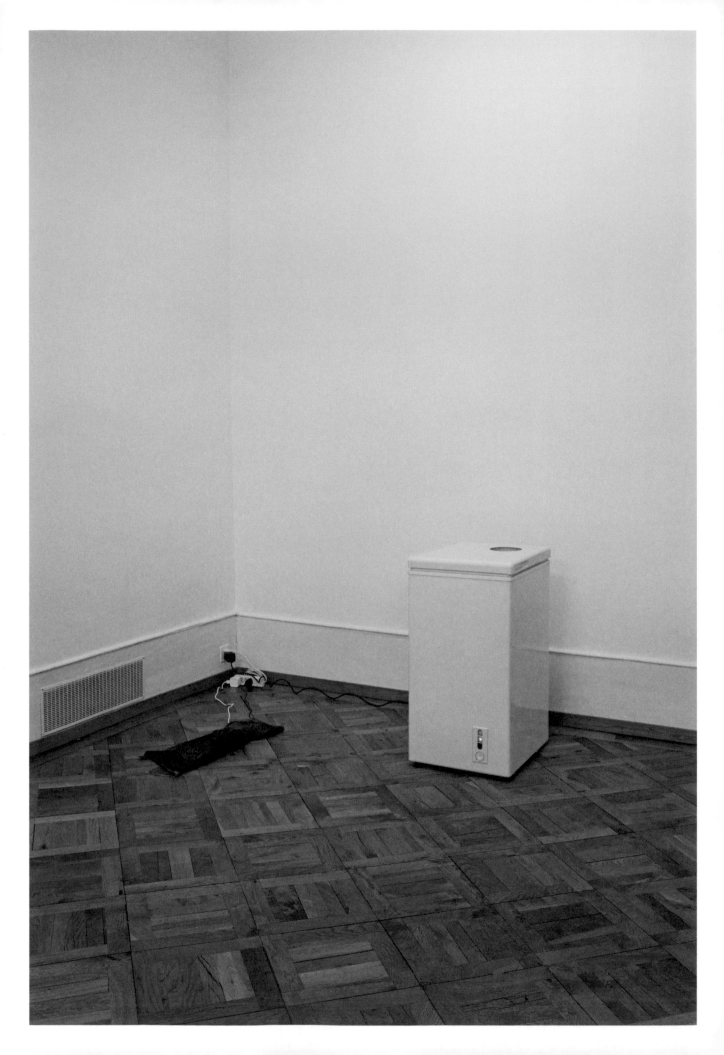

INTERVIEW WITH ROGER HIORNS
Felicity Lunn

If we make a decision to act against the surface, if we want to react and tear into these fearful surfaces we must act in an unanticipated manner, we must make a decision to move and act out of place, an idea must be placed up against the thin but resistant walls, and the idea must be worldly, it must take the human with it. Roger Hiorns

FL: Roger, the presentation of your work at Kunsthaus CentrePasquArt is your largest exhibition since your show at De Hallen Harlem at the end of 2013. It is an opportunity for you to assess how your work has developed in the meantime. What drives your practice at the moment?

RH: Rather than there being a definitive starting point, I tend to drift into new work as a continuation of on-going concerns. I want to track and examine how social problems can be addressed through the adaption of objects. The various series of work I've made for the show in Biel have taken most of the year to produce. They represent the culmination of a group of ethical and social concerns. Expressing these concerns verbally always worries me, though, as putting ideas into words can so easily close the door on them.

FL: It's interesting you should say that as you're extremely articulate about your work and seem to enjoy talking about it!

RH: The words attached to art influence a person's approach to it. On the other hand, the works will eventually lose the words they amass or at least the words will be different in another time and context. The language applied to objects allows us to negotiate with them and yet I believe, or suspect at least, that the visual is always superior to the verbal. Any objects or adapted artworks demonstrate the priorities of the time in which they were made. They nominate what was collectively important for an audience at a given moment.

FL: What stands out for you in the present?

RH: I'm suspicious of much artistic output at the moment. There's a clouding of the distinction between the intellectual object and the work

of art created for the market. A big issue for me is how to separate the two, to identify what may be useful, what is worthwhile and allows for a wider outlook than the usual undervaluation of human potential. I make art that helps the world.

FL: You said a moment ago that your work is driven by both ethical and social concerns. How do these manifest in your work?

RH: In the studio, when I'm considering which ideas to develop, a set of environmental facts is uppermost in my mind. Recycled materials are at the heart of a number of works, for example the installation of *Beings* is constructed almost entirely from the plastic forms of discarded car engines. The *Beings* themselves have a bent anthropomorphic figurativeness: I consider them as having both sentimental and rather judgemental, mean-spirited qualities. They're rather complex, it seems. As a group of 200 objects, as a gang, they can demonstrate how reductive we can be as human beings in our dealings with each other. I'm in the process of researching BSE, the so-called Mad Cow Disease, which affected the UK and parts of Europe from 1986 to the present day and is the subject of an exhibition I'm curating for London's Hayward Gallery. The crisis was caused by a forced relationship between a population and a predatory capitalist system. Since the British state prioritised the needs of industry over the health of the public, the population of the UK was exposed to a damaging agent with the potential to cause brain disease. I believe we need to be more vigilant about how we're coerced and pushed around by the authorities. The installation consists of a group of 200 plastic forms, some of which emit foam: my sympathy is with them.

FL: Your own response to the installation *Beings* – that will occupy our 365m^2 cube in Biel and therefore be the key feature of the exhibition – is highly ambivalent.

RH: The *Beings* are a single, amorphous, generic entity. At the same time, they have certain individual qualities. In the studio I like to anthropomorphise and sentimentalise them, though the words I choose to describe them vary: I regard some as being nicer, better mannered than others. It's possible to talk about them as people and to feel affection for them in the way one might for a cat or a baby.

FL: You've approached your solo exhibition at Kunsthaus CentrePasquArt as an opportunity to develop and produce several bodies of work that have existed in your head for some time. However, you've had a sort of trial run for the *Beings* by showing them in your gallery in New York at the end of last year. How did people respond to them there?

RH: Of the 200 *Beings*, I showed only 16 in New York and there was a mixed reaction. Some people didn't warm to them at all and others found them repellent and grotesque! I like New York, I'm an outsider there, so contradictions in the artworld seem to be heightened and alien. The ultra worldliness is intensified by a very fluid market, quite a mix. I felt unsure about how to present the installation, since it is a new work and it takes time to understand how these *Beings* operate in the world. What I mean by this is that, in opposition to the Modernist credo, art and its rarified objects have an inherent autonomy. It is possible to display relativist objects in a commercial environment and to then enjoy the contradiction, to learn from the experience.

FL: Can you explain a little more what you mean by this?

RH: Both the production of art and the dialogue surrounding it are relativised by their context. Art shows us the world more clearly but there are no absolute truths. I think it's important for an artist to be aware of the mechanisms that exist for making and showing art and of their inherent contradictions. It's possible to be secular in outlook but also to develop a way of looking at art as a "believer". *Seizure*, the installation of copper-sulphate crystals I made in 2008 in an abandoned London council flat, is a pertinent example. The intense blue of the work, together with the concentration required to experience it, enhanced brain frequency, intensified attention. It became well-known in Britain as a spiritual place, cultish and of another world. I really think it was an object that allowed the viewer to become more attuned to their personal worldliness, that attention got unlocked. It has also been noted in its new location that sexual activity goes on inside the sculpture. In other words, the result of the experience of the work is sexual arousal.

FL: What, then, would be your ideal environment for the *Beings*?

RH: My studio is in a location that is surrounded by council flats which makes me very aware that my objects exist among people. There's a large immigrant population on the estate that would, in theory, allow for a huge variety of cultural readings of the *Beings* and destabilise the western reading that we continue to prioritise and that I much distrust. Children often wander into my studio and ask questions and play with the objects. They have a very tangible affinity with the work that isn't reduced or threatened by its ugliness and odd qualities. It seems the only way to be close to the *Beings*, day by day, is by owning one but it's possible for me to share the work by showing it in the public space, of course. I am also tempted to give one away to each household on the estate, something I'll certainly look into. The large immigrant population that surrounds the studio is, I must say, the key influence

on the work. To be able to create within an environment of no precise cultural legibility is a very special position.

FL: Though this varies hugely too. Presenting the *Beings* or the *Youth* series with the naked performers in Biel will provoke quite different responses from exhibitions in other places or, indeed, at other times. How do you consider the temporal context for your work currently?

RH: Well, it seems to me that there is a strong focus on atemporality right now. We're living in a period where everything in the past and in the notional future world coexists within the present, the dream of which is a deliberately clean break from the past. We're striding through a constant and crystalline presentness.

FL: You seem to be suggesting that society in general has lost its way. Is this something that you consciously aim to address in your work?

RH: I do think we've drifted away from an understanding of how to lead our lives in a full and truthful way. We're locked into a peculiar kind of behaviour in which we are no longer able to tear into the interlinking surfaces that form our realities: we seem only to manage to dig our toes in slightly and are simply reflected in the surfaces that surround us. The system's impressive defence is our own haunted reflection mirrored back to us, an ego deterrant. Surfaceness, well defended realms of capital and marketing are in every aspect of our lives – the home surface, the job surface and the travel surface – and they are impeccably prepared for us. They anticipate every move we want to make, every decision on diet and entertainment; life itself is a trap that keeps us skating dissatisfied and limited from one surface to the next, on surfaces that are highly formalised.

This is in my mind when I make the *Youth* pieces, where I try to find and accentuate the gaps in the smoothness of the neo-liberal worldview. I was fascinated by the student protests and summer riots in London in 2014. At their core these were about a resistance to the homogenous surfaces of our living systems that shut out what or whoever doesn't fit a clean appearance and a willing CV.

FL: Can you say more about how the *Youth* pieces are informed by this aspect of our society?

RH: Well, they're about a constant present. The youths sit on the objects that are activated by fire. Whereas sculptures inevitably age (ideally) and sometimes become embarrassing with time (usually), these machines shrug off the possibility of aging. The renewal of young men is part of the sculptures' origin, a desire for eternal youth. We come back to the

subject of the atemporal. The art world has a mechanism that allows this idea to be reality in terms of conservation, a kind of life support system that prolongs the longevity of aging artworks and keeps them stable for as long as possible.

There is a literal quality to these works that also informs the paintings made with cow brain matter. These are essentialist artworks, in that they are about keeping the structure of the mind, the brain, present on the surface. A new surface is created in opposition to the trap surfaces I described earlier. The cognitive ability of the cow that was once standing in a field was to assess the view. This mechanism is now on the wall in front of us, a new object. I wonder sometimes whether these works might indicate the possible future of painting: representation and technique as belonging to the past. This would put an end to the psychological nature of figurative representation and the emotional basis of abstraction, replacing these with the cognitive semblance on the surface of a piece of square plastic. It seems to me that a link is made here to painters such as Gerhard Richter who has flattened and expanded the picture plane throughout the course of his career. He has striven to reach a total surface, one that can hold a heavy weight of visual information alongside all past and future possibility. What better thing to display as a surface than the mind itself? Of course the paradox here is huge: I try to evoke an ending and a progression at the same time, and I try to do this with the arcane mechanism of painting. There's a lot more to say on this.

FL: This is quite a radical idea, almost verging on the dogmatic.

RH: Yes, there's a totality to the cow brain matter paintings, a kind of deadness and truthfulness. In a less direct way the same can be said for the works that sit on the floor, dispersed through the exhibition in Biel. At the heart of the piece *Untitled* (2014) is the emission of radio programmes from a BBC series that examine – in terms of medicine, science, religion etc. – where we are in our world today and how we have to negotiate the future. One programme, for example, concerned a dying Muslim man and the discussion with his family about the end of his life. Since the Koran doesn't deal with the ethical issue of life support machines the decision had to be based on other considerations that took into account both Islamic and western customs.

FL: What's the significance of the latex sheets in this work?

RH: The floppy, rubbery material surrounding the speakers underlines the ambiguity of the subjects being discussed in the radio programmes. People shouldn't be told what to think or do. If they are able to have religious faith, they should have the freedom to do so. The most important

thing is to talk about ethical and moral issues, to be in tune through certain activities. This extends to the *Youth* pieces and the question as to whether the boys are being used as objects? I'm trying here to address an unsympathetic aspect of the human psyche and our relationship to objects. It's a complicated activity we've found ourselves involved in: we shore ourselves up with objects that increase our productivity but these also accentuate parts of the psyche that it would be better not to address. We can add a systemic violence to the value of an object and reproduce that object industrially; the object can then act as a lever to force a societal move, something that happens daily. The object can act as an agent of a further foreshortening of the human's potential; it can shut down the human's progression. This is, of course, useful if you want to control a population. The spy jet engines that constitute a sculpture I made in the US, is the epitome of this. I had to negotiate with the private company that owned a pair of US spy plane engines in the United States. They had the choice whether to sell the aircraft engines to me for my exhibition in Chicago, or allow them to be sold as part of a surveillance system of the Israeli military airforce. This was a very problematic decision for them to make. In the end they chose a cultural outcome over a military one.

FL: It's clear that for you the production of art is inseparable from taking a responsible position on world events or moral issues. As an artist, however, you can't avoid having a certain power relation – via the art object – with the viewer. Doesn't this ever become overwhelming?

RH: I'm always very conscious about how the viewer relates to the objects I make. I produce a large number each year, but sometimes a single object such as *Seizure* is enough to have a very powerful impact. However, I'm also able to create work that is less attractive and, in doing so, to map out the viewer's responses to an unanticipated object or arrangement. A significant aspect of my work is the decision about whether the thing needs to be done at all. Perhaps I will be judged eventually on what I did not make. There are more works I haven't made than have made and it is important that I didn't make those works.

FL: You tread a fine line between, on the one hand, an instinctive sense of which objects might be adapted to address particular issues and, on the other, stepping aside to let the work generate itself. In works such as *Seizure* or the *Youth* sculptures you allowed the physical execution of the work to be informed by chance processes and situations that were beyond your control. Why is this important to you?

RH: I'm an artist who makes art and not art about art. I'm not interested in re-hashing existing ideas for their financial benefit. Even if

it's delusional, I believe that the artist's role is to move us on, to hold up a truthful mirror in order that progress might continue. Frankly I'm suspicious of many of my contemporaries who make work that simply reflects the desires of collectors: they're reinforcing the surfaces, I think. I find artists fascinating in the same way I'm fascinated by how machines and systems function.

FL: Is this interest in the world around us at the heart of a further work shown in Biel, the on-going series of photographs that you started as a student?

RH: Yes, I kept this work well hidden, but this time I'll be trying out a way to deal with these images in an exhibition at last. I want the work to present a low value status to the viewer, perhaps in a manner similar to a universal marketing display, a display where they become difficult to be portable. I think I have a method, nothing clever, quite the opposite.

nologue frame A

SCREAMING FRAME A

☼ US

8

Monologue frame B

9

10

11

12

13

14

15

6

X3

Yoctta
under
Table

ROGER HIORNS
THE DUST OF THE MODERN
J.J. Charlesworth

Sacred, institutional, industrial, carnal, ritual, biological, religious, diseased, technical, cerebral, communal, hygienic. These are strange terms to put together, side by side. We have an urge to separate them out, arrange them in more comfortable groups, like letting oil and water, churned up in a glass vessel, slowly de-emulsify, re-coagulating into distinct and insoluble elements.

Sacred, institutional, industrial, carnal, ritual, biological, religious, diseased, technical, cerebral, communal, hygienic. If these terms seem incompatible, they are nevertheless invaluable in describing the combination of themes that operate throughout the work of Roger Hiorns. The artist presents us with a bleak, uneasy landscape that, while seemingly dislocated from the modern world, nevertheless operates in and through its objects, materials and systems. It is a world of technically modified matter – detergent foam bubbles produced by compressors; cold sheets of latex rubber; pure alcohol burning in cotton wool; mechanical parts ground to dust; the brain tissues of animals smeared on fibreglass; semen wiped over the surface of light bulbs; accumulations of contact lenses and the oval windows of passenger jet aircraft; radios set to speaking to no one; car engines encrusted in blue crystals. It is also a world of actions performed or proposals for actions that might be performed: naked young men sit and contemplate fires set burning on disused jet engines or park benches; prayer groups instructed to direct their prayers towards inert objects or technical sites; a proposal for the burial of a passenger liner; the possibility of installing open shower facilities in the shadiest areas of a park; the repetitive, continual disinfection and cleaning of a fountain and a monument in a city, by a social group who might or might not be religious.

These are uneasy oppositions – live matter and dead matter; organic substance and inorganic substance; human technology and chemical entropy; the signs and metaphors of human erotic existence (naked men, semen, fire, conjoined part-animal, part-human figures) against the regulating forces of social institutions and rituals; the spiritual (prayer) against the reality of consciousness in its material form (brains). But Hiorns wants to conflate and combine them, in a sort of calm, unblinking provocation, provoking us to consider that what is being combined are not merely materials and actions in unusual combinations, but in fact the iconic representatives of human existence as we conceive it today. These are icons that mark out the condition of modern society and modern culture from that which has preceded it, a condition that is, however, now fragile and prone to disintegration. Hiorns's work operates like a barometer for the uncertainty of what constitutes human being in a century

of pre-modern returns and post-human arrivals. Hiorns's work – if it could be described in extreme summary – envisions the dilapidation of human agency and the deceleration of human history, to be replaced by the repetition of ritual and the indifference of physical entropy.

If Hiorns's work channels and concentrates the stresses and ambiguities of our current era, then maybe it is worth briefly reflecting on what characterised the 'modern moment', and why it might now be starting to disintegrate. Among these characteristics we might point to: the supplanting of religion by science; the dissolution of ritual by reason; and the decline of spiritual perspectives in favour of materialist interpretations of human existence. If the pre-modern world was one characterised by certainty and belief, then the modern world is characterised by scepticism and questioning. If the pre-modern world fantasised about overcoming the limits of human being by creating an imaginary world of gods and magic, then the modern world has made the overcoming of human limitations a reality through science and technology, by the ever-accelerating invention of prosthetic mechanisms and systems that extend human capacity and agency.

Today, however, those modern values, which took hold with the Enlightenment and had such influence over the next two or three centuries of political, cultural and artistic thinking, are themselves subject to acute uncertainty. Reason, rationality, science and technology are no longer seen as unqualified, progressive developments. The ideal of social and human progress is often seen as a wishful delusion at best, materially destructive at worst. Human consciousness and free will is treated with profound scepticism by developments in philosophy, psychoanalysis and neuroscience. The once privileged status of the human mind is now brought down to be equivalent with organic and machine processes.

These might be big claims, out of which come some substantial political and philosophical questions. Hiorns's gestures of recombination seem almost to celebrate the disintegration of what we might think of having been the 'moment' of modernity. And if they are not celebrations, then at the very least Hiorns's works are impassive harbingers of that disintegration, which is now starting to become evident in the cultural and intellectual discourses of our advanced and increasingly disenchanted modern world.

Hiorns's work probes this cultural condition with an increasingly unnerving acuity, more so because it avoids any explicit, obvious rehearsal of the tropes of 'political' art. Instead, it presents us with relics and rituals that appear as the ciphers for a decaying modernity, in which old dualities and oppositions are fused and reintegrated. This fusion is most literally realised in a work such as *Untitled* (2014), in which an aircraft engine is ground to a fine dust and scattered on the ground, mixed with the similarly atomised remains of a granite altarpiece. The mixture is as much symbolic as it is material: faced with this melange of dust, we are forced to witness our own mental associations – about faith and science – become physically miscegenated in front of us. Conflicting ideas become combined matter. If 'miscegenation' seems a harsh

metaphor to use, it nevertheless seems the right way to describe Hiorns's carefully gauged cross-breeding of cultural, existential antitheses.

So, in Hiorns's exhibition for CentrePasquArt we find a vast grouping of hanging assemblages, made of redundant car engine components – the bulbous polypropylene containers for air conditioning fluid and screen-wash, rubber cable ducts and ventilation hoses and bulky, angular water reservoirs. Some of these rudimentary figures produce detergent foam, but most merely hang, silently, and while they immediately suggest human form, it is nevertheless a degraded kind of anthropomorphism we are faced with, rather than the presentation of emphatic analogues of arms, legs, hands and mouths, as you might find in primitive sculpture, or in the modernist sculpture that once drew inspiration from the vitality of primitive art. Nor are these the heroic, revolutionary Man-Machines of twentieth-century futurism. These figures hang like dismembered remains – torsos, entrails, spinal cords and sphincters.

Their feeble anthropomorphism is one of innards, of the machine-like biological processes to which the state of being human is tied. Unable to transcend it, the human subject is bound to its organic materiality, and Hiorns's work forces us to reflect on whether there is anything beyond this. In another group of work, audio players are wrapped in sheets of skin-like, yellowing latex, lying on the ground. These devices are set to play recordings of 'Inside the Ethics Committee', a discussion programme broadcast since 2005 on the BBC's Radio 4 station. In the programme, experts in the field of medical ethics discuss the moral and scientific conflicts between medicine's duty of care for its patient and the individual's right to determine how they are to be treated, how to live and how to die. From inside their aging latex shells, the voices of the committee consider the distinction between body and mind, between the failure of the body and the failure of the self, itself a product of the physical organ of the brain.

Brain matter is a recurring material in Hiorns's work, desiccated and inserted into objects or, as in work presented here, dissolved and smeared (or 'painted') onto panels of fibreglass. Like the powdered remains of jet engines or altarpieces, their power is not in their visual form, but in what they symbolise – the matter that once formed the conscious mind of a living thing. They are conceptual short-circuits, since the only thing that can give them meaning is the thing that is looking at them – eyes linked to a brain. Our brains, matter made conscious, contemplate consciousness turned back into matter. Neither is it surprising that the act of looking and the material of looking has appeared increasingly in Hiorns's recent work: not only in his use of objects such as contact lenses or the windows of jet planes, or even in his reuse of the engines from a decommissioned US surveillance aircraft, but in his *Youth* performance/objects, in which naked men periodically light and observe small fires until they go out. Visual perception itself becomes a kind of physical object, and looking becomes an act abstracted from human intention.

A common thread links these works, then: something to do with the presence of passivity, inertia, and entropy. While Hiorns's works often contain

forms of energetic release, such as fire or the forming of bubbles, these are nevertheless contained and minimal. Previously powerful machines are rendered inert, or through a huge expenditure of effort reduced to fragments. Figures hang or sit, rather than stand. Hiorns's various instructions and proposals direct people into ritual, regulated activities, carefully prescribed. Human bodies are organised and scheduled in interactions with cold objects. What human energies are present in Hiorns's work are the indications of human processes, in the recurrent use of semen, or the references to digestive, genital and faecal activity. And yet even these seem present as physiological indexes of human beings as merely material systems – thoughtless and driven simply by the genetic imperative to continue to exist.

But perhaps Hiorns's works are also appropriate echoes of the contemporary world's sense of uncertainty and disaffection with what human beings are and human society is leading to, as what constitutes the 'modern moment' slowly recedes. After all, it is only now that the rationalist, materialist perspective that emerged in the modern era is being applied to human consciousness itself. We may have long ago abandoned any belief in the spiritual world, but we now begin to wonder whether this thing called human consciousness is really any different to any other physical process in the world, while the rapid development of network technologies and artificial intelligence makes many question what post-human form consciousness might yet take.

Hiorns's work increasingly charts this strange ambivalence with a sense of anarchic exuberance. And yet, in the artist's appropriation of the forms of ritual, there is still perhaps a perverse and subversive gesture against this pervasive and reductive materialism. Perhaps it has something to do with how people create meaning, and how ritual codifies and perpetuates those meanings. And maybe that has something to do with art, in the sense that human art is the lasting trace, in the shaping of matter, of human presence in the world. Maybe, in an extreme form, Hiorns's objects present us with the minimal condition for what is and isn't art, as he reflexively traces the borderline of what might or might not be human. A first, or last line, traced in the dust of the modern.

Dusty pink tiled
sound object
for bag work

CRISTAL CONTAINER IN
FIBRE GLASS

RULING N...

THE BODY PERCHED
ON TIME
THE BODY CARESSED
BY EVENTS

Arnolfini with
giante boy.

new
variant figure.

↓ Untitled

foam pocket.

foam
tubes

latex
and mesh
and
flesh resin
↓

Dust
wash
out
of
ass

5″

In recent years, Galerie Rudolfinum has increasingly focused on the contemporary British art scene through both solo exhibitions (Jake and Dinos Chapman, Damien Hirst, Raqib Shaw) as well as group shows (*Model, Beyond Reality: British Painting Today, Cake and Lemon Eaters*). When considered in relation to other previous exhibitions (e.g. Damien Hirst, *Reality Check*), these shows should not be seen as isolated looks at the British scene; rather, they represent a systematic effort at placing British artists not only within their mutual context, but also at defining the British scene's relationship with artists in the Czech Republic and other European countries. The solo exhibition by Roger Hiorns is thus more than a mere presentation of an interesting representative of the young generation of British artists, but a logical continuation of the gallery's exhibition programme.

Whereas the earlier generation of "Young British Artists" created works promising a visual spectacle in terms of size, choice of materials, and references or citations both shocking and easily understood, Hiorns works in a different spirit: he creates literary narratives that are both layered and expansive, with the works' individual elements emerging in a provocatively ambiguous manner. This ambiguity resists a simplistic interpretation of the works, is not easily described, and is not satisfied with accepting the first level of meaning or symbolism that presents itself. Hiorns represents a generation that has been strongly influenced by conceptual approaches but that is also more engaged in taking a stand against the changing nature of authority and power structures in today's Euro-American civilisation, including the related societal schisms. This series of independent exhibitions at various institutions, as part of which this catalogue is being published, consists of new works, old works that have been modified or further developed, and site-specific installations whose form and content take shape during their realisation within the gallery space.

Let us pose the questions that arise when we consider this presentation of works, and let us then answer them over the course of the exhibition. *When did people last walk naked? When will they again walk naked? How close do we come to another person's naked body when we are alone, and how close when we are being observed? Is the temporary nature of the naked model in the gallery related to the temporary nature of the gallery visit? Does the material nature of the installation act as an anchor within an insecure interaction for both participants of the encounter (the model and the visitor)? Does this anchor apply to the interaction between exhibition visitors? If we transmit*

sound from one space to another, to what extent do we give it a new dimension and to what extent do we destroy its authenticity? Will we go to the space from which the sound is being transmitted into the gallery, and thus sonically manifest ourselves there? Do we feel better in the role of voyeur and spy in a sound medium, or in the role of victim? If we look at the exposed innards of an automobile, do we then also consider the outer shell with the innards concealed? Do such considerations have an influence on the power that machines represent? Are we aware of whether our personal power is influenced by our surroundings? If we are caught in this onslaught of questions, do we have control over our own power (as artist, curator, or recipient of the artwork)?

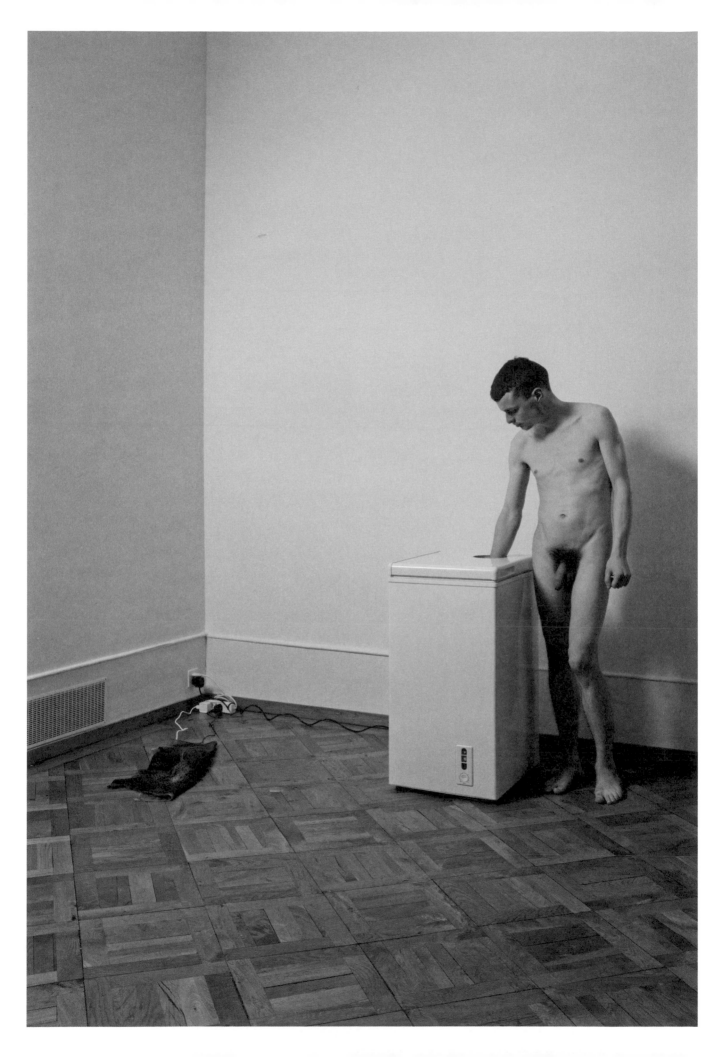

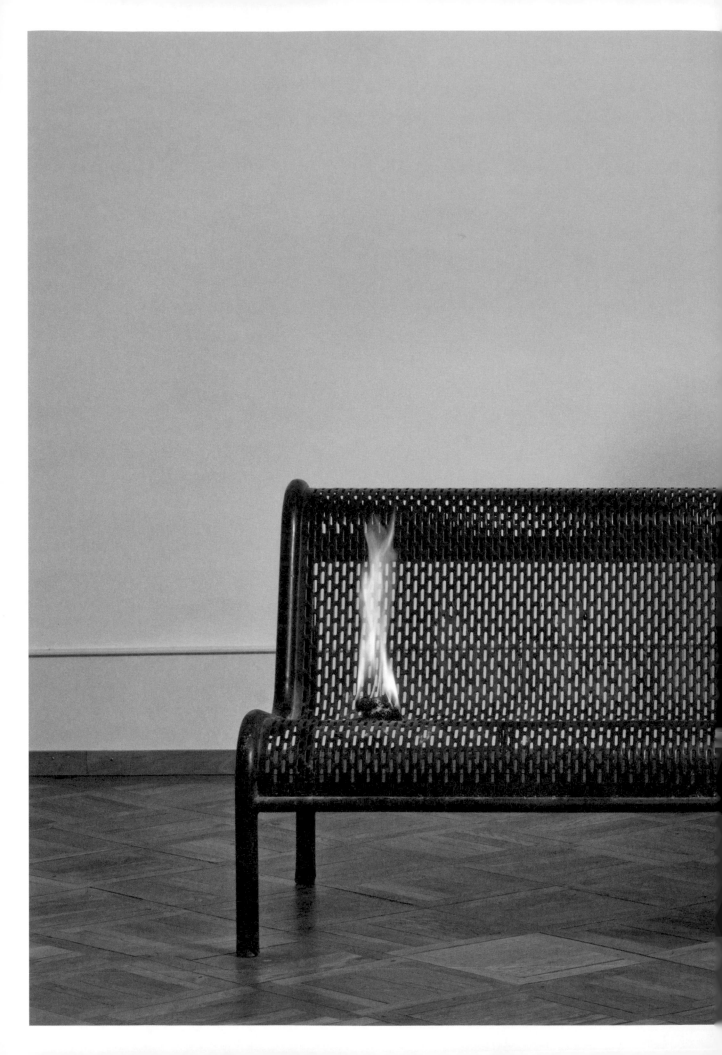

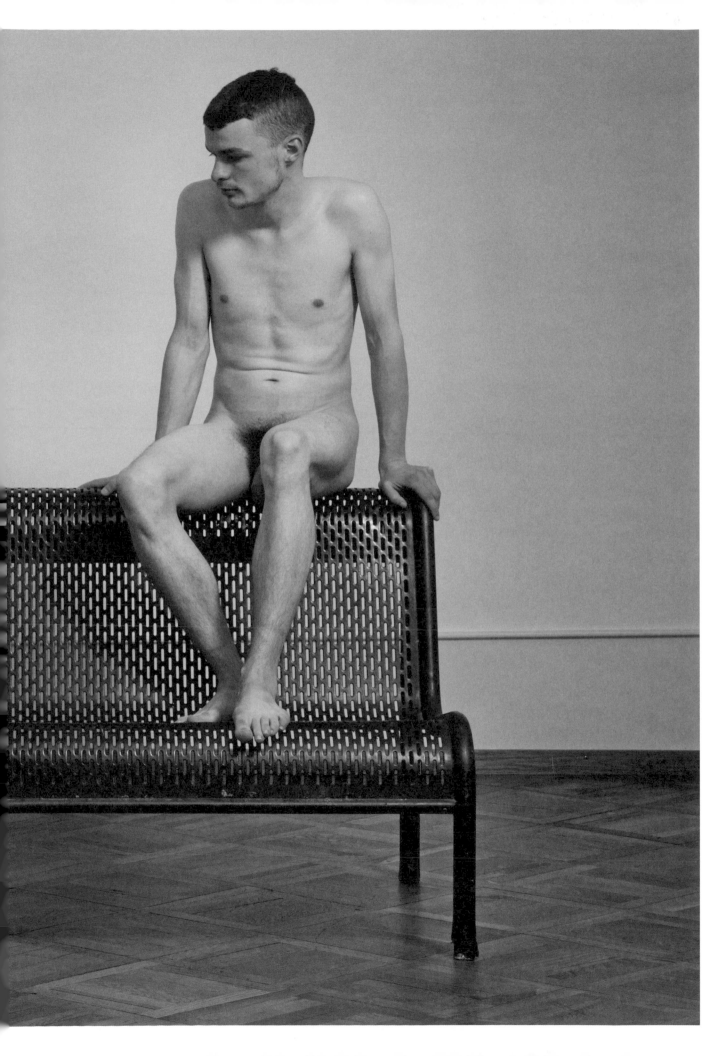

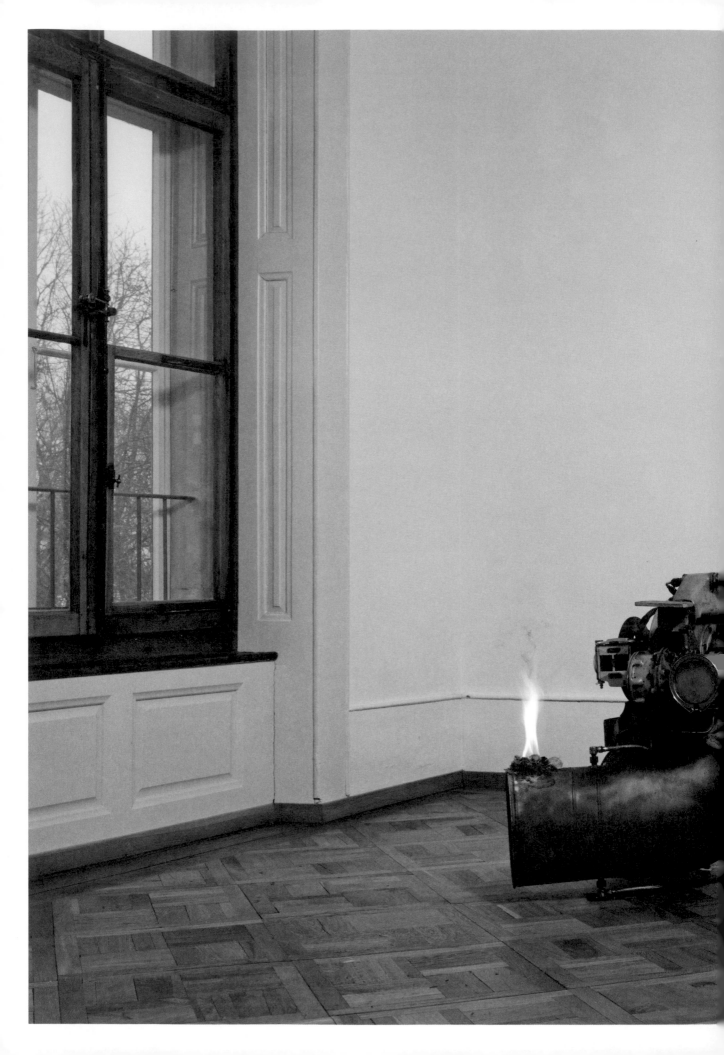

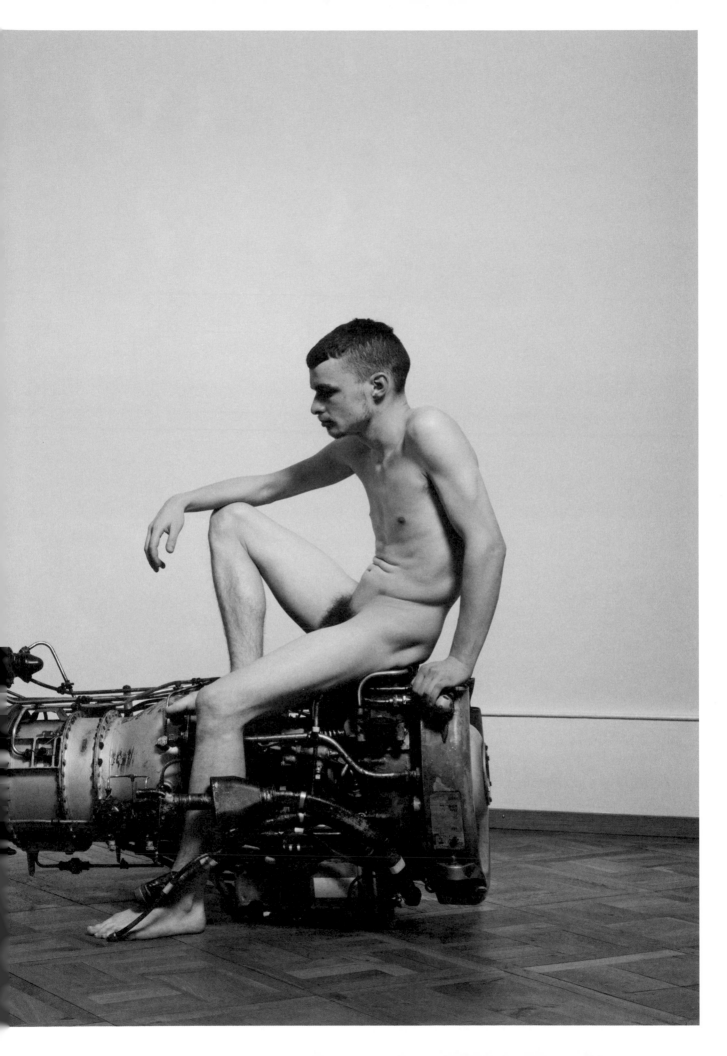

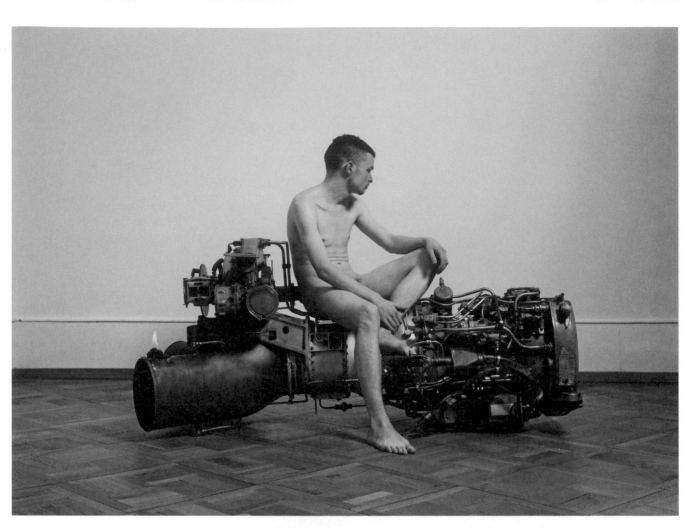

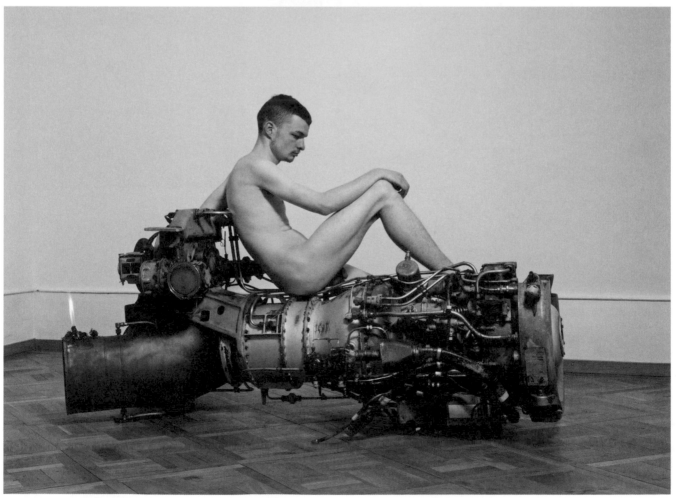

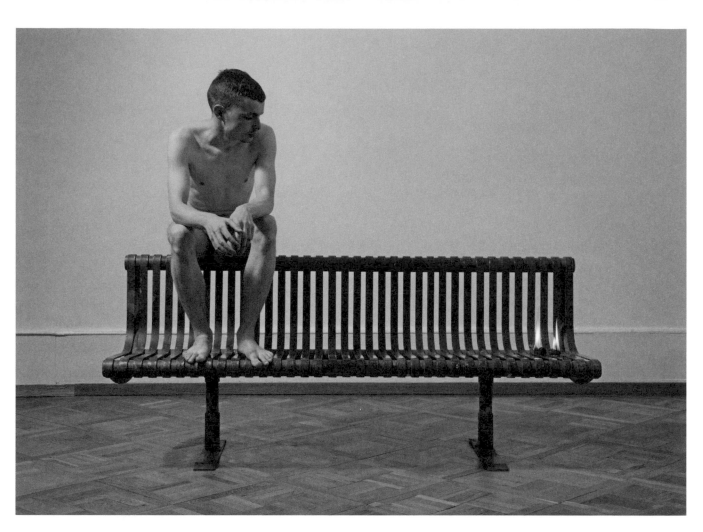
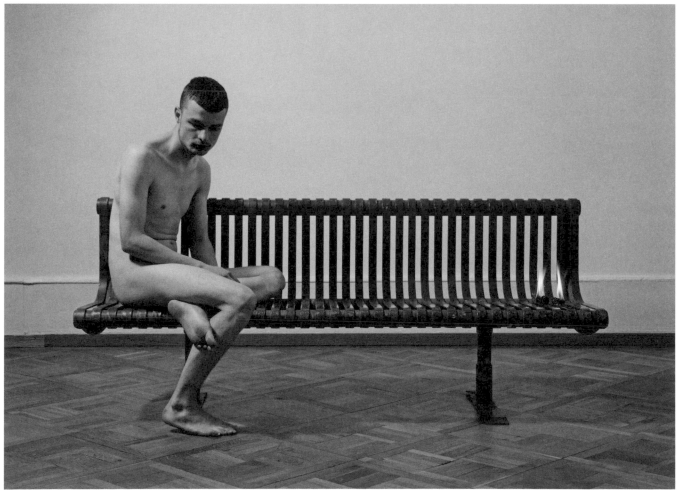

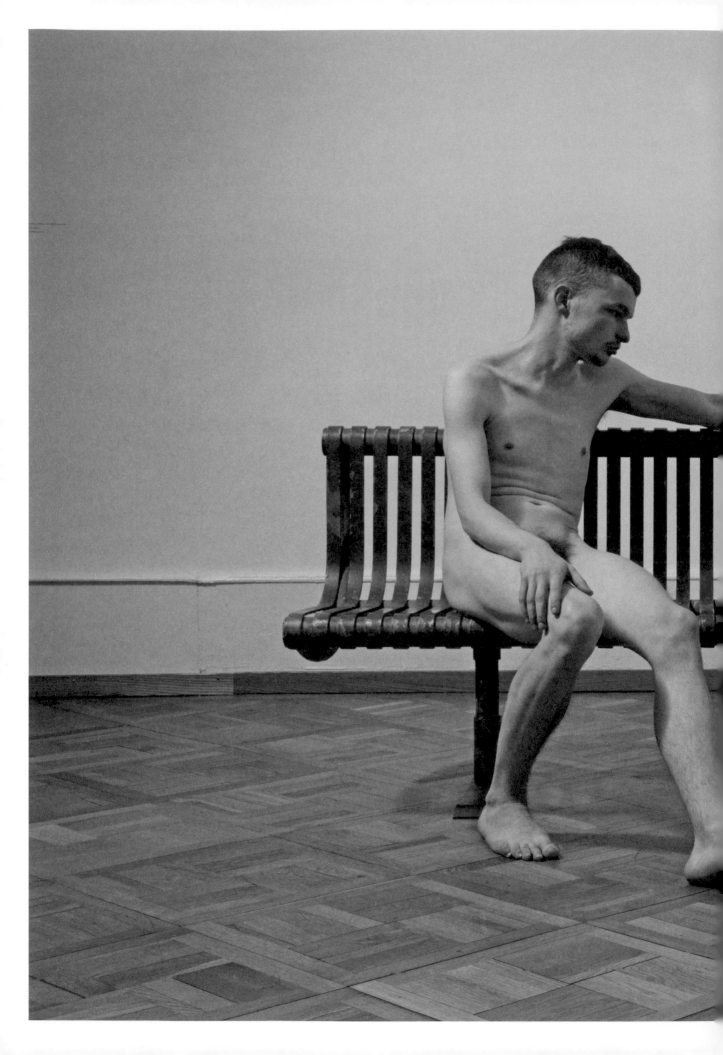

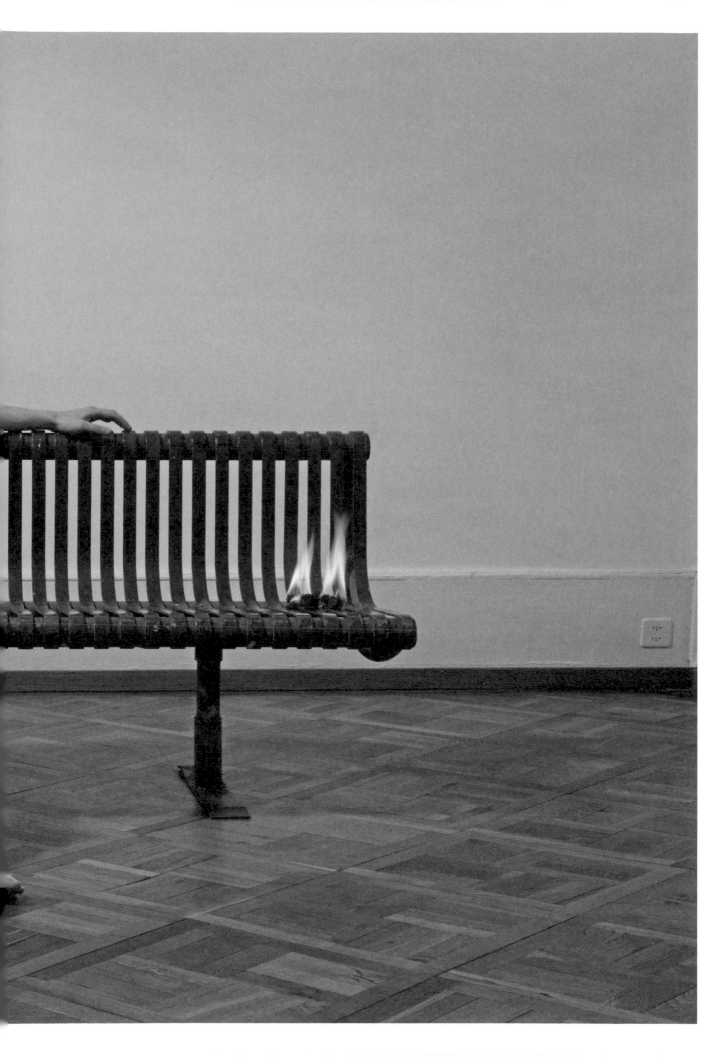

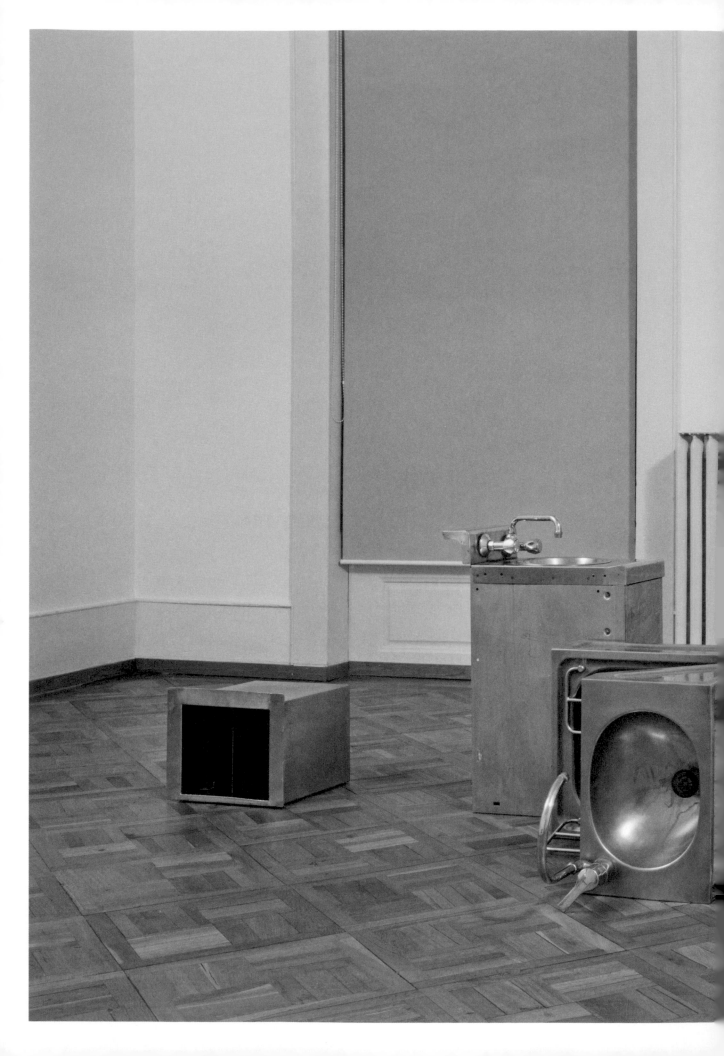

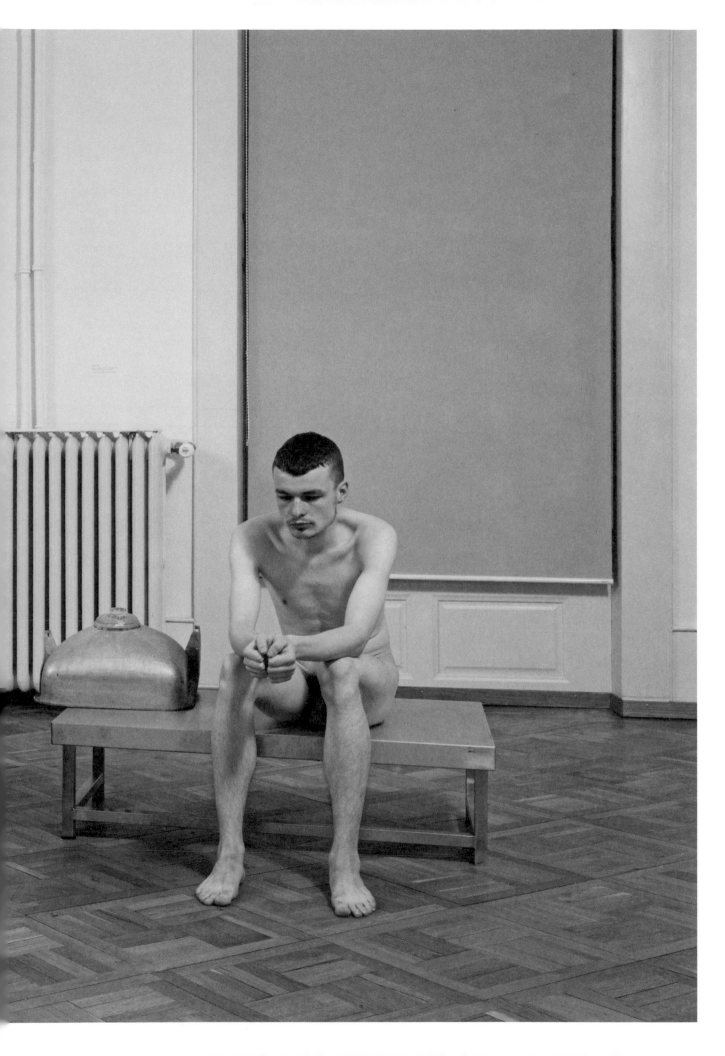

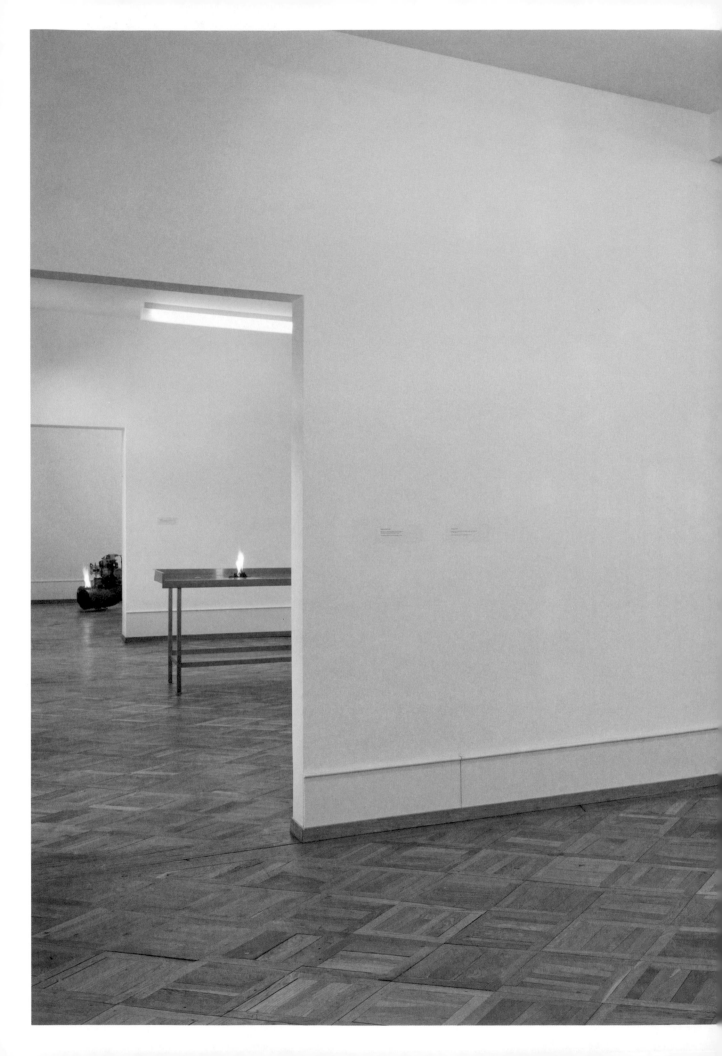

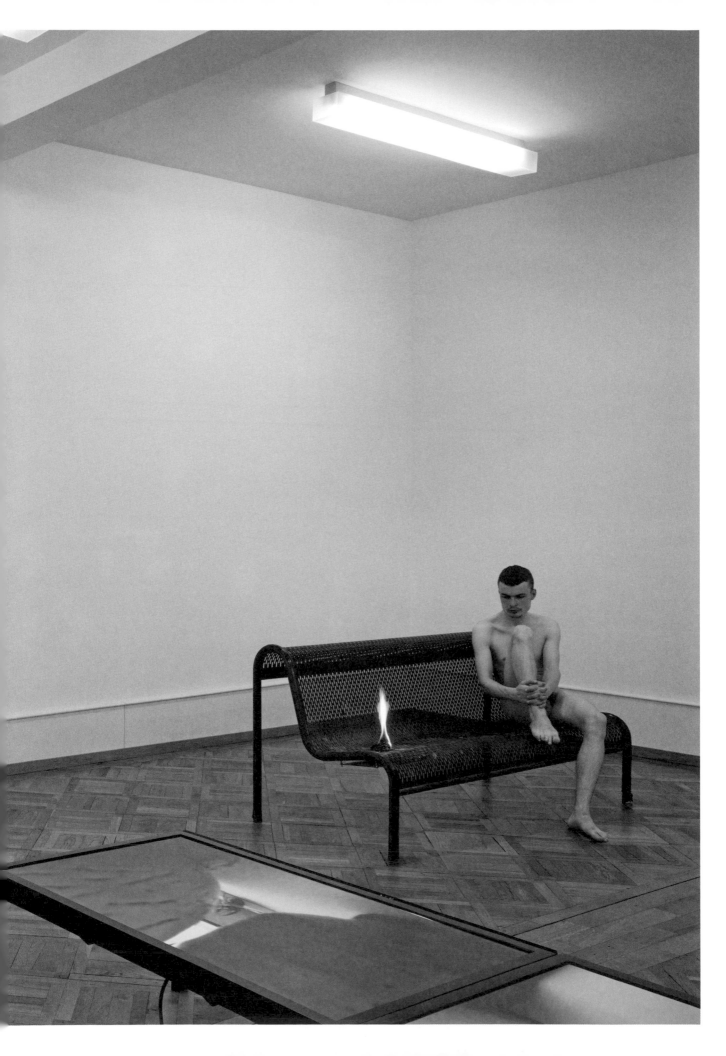

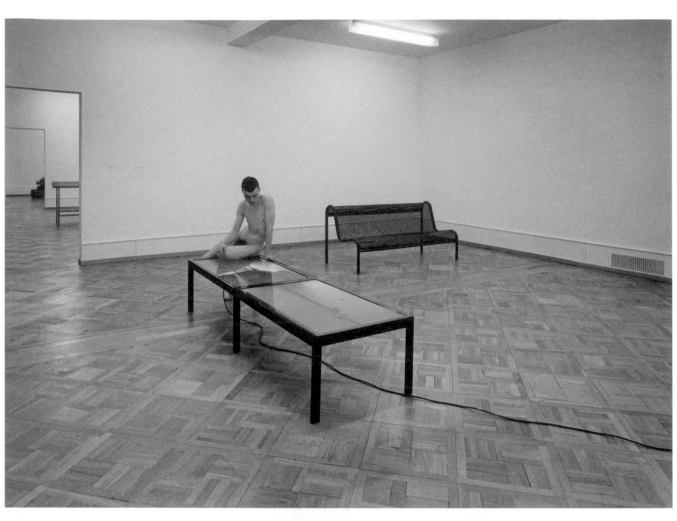

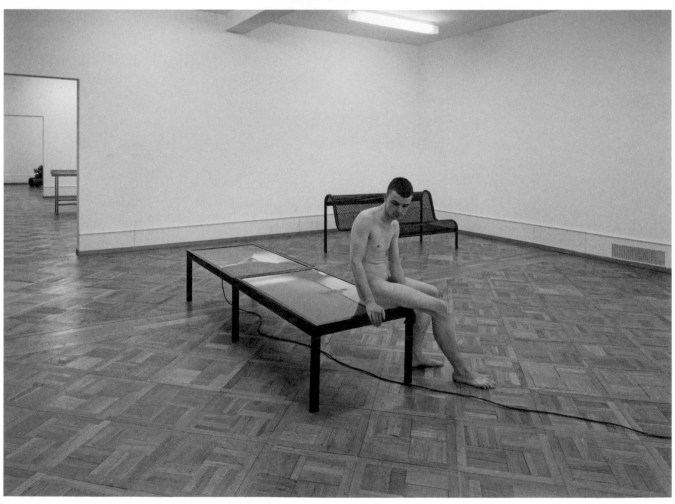

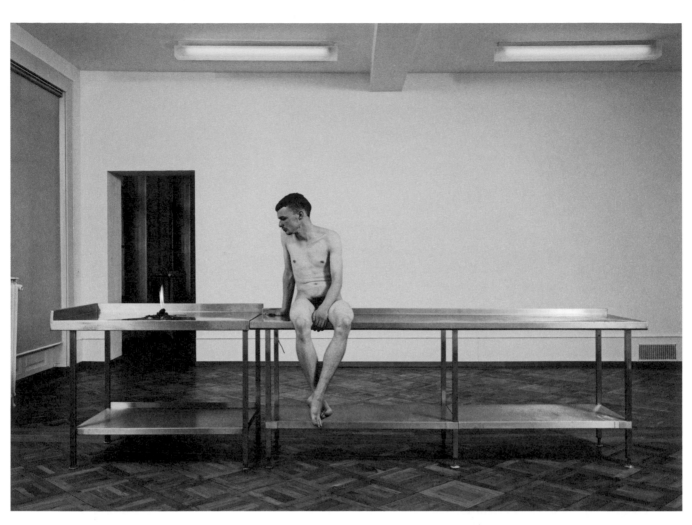

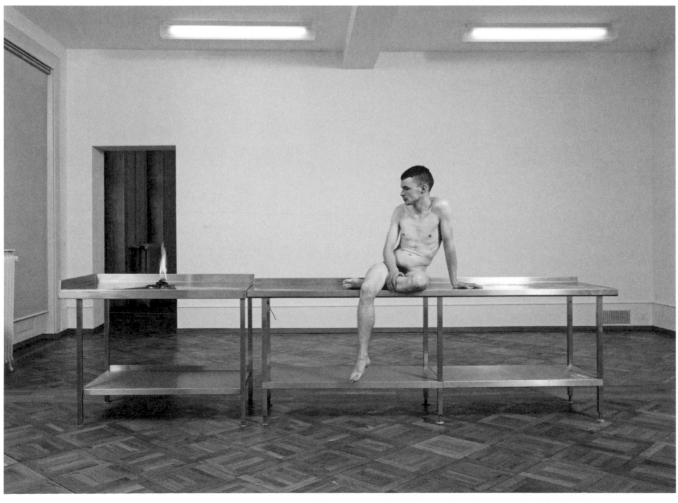

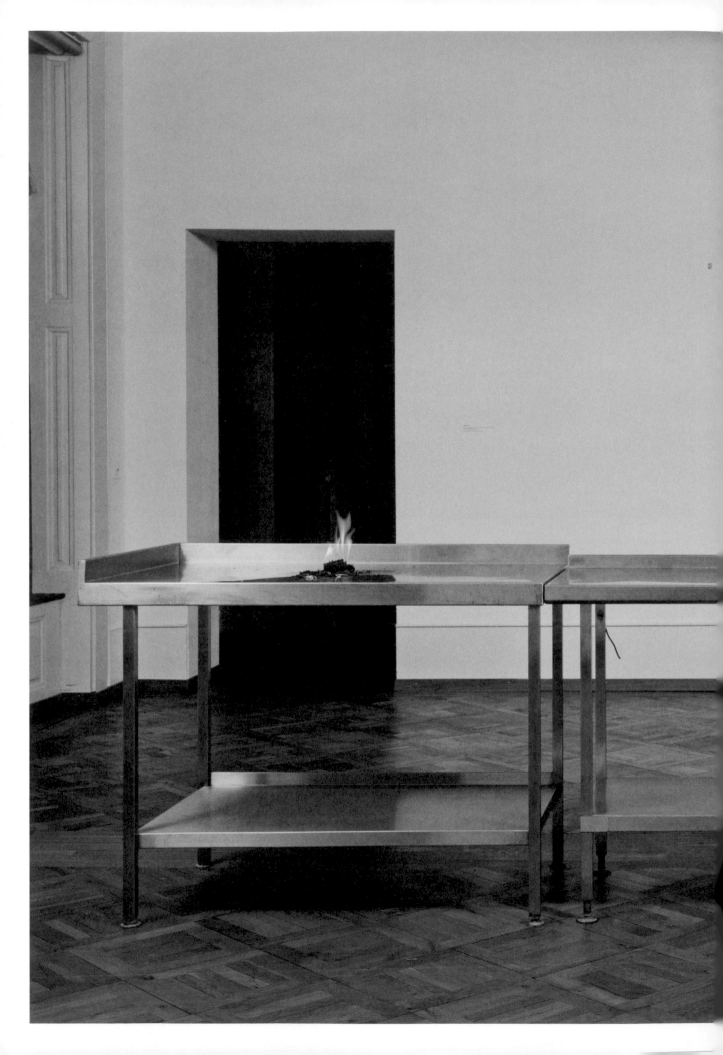

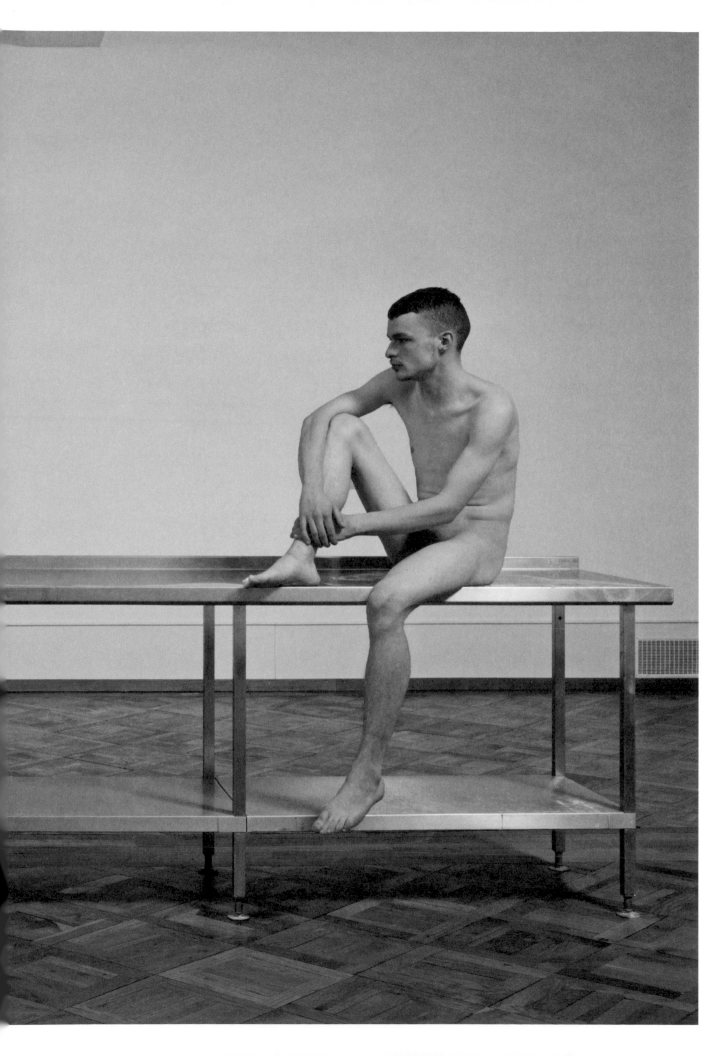

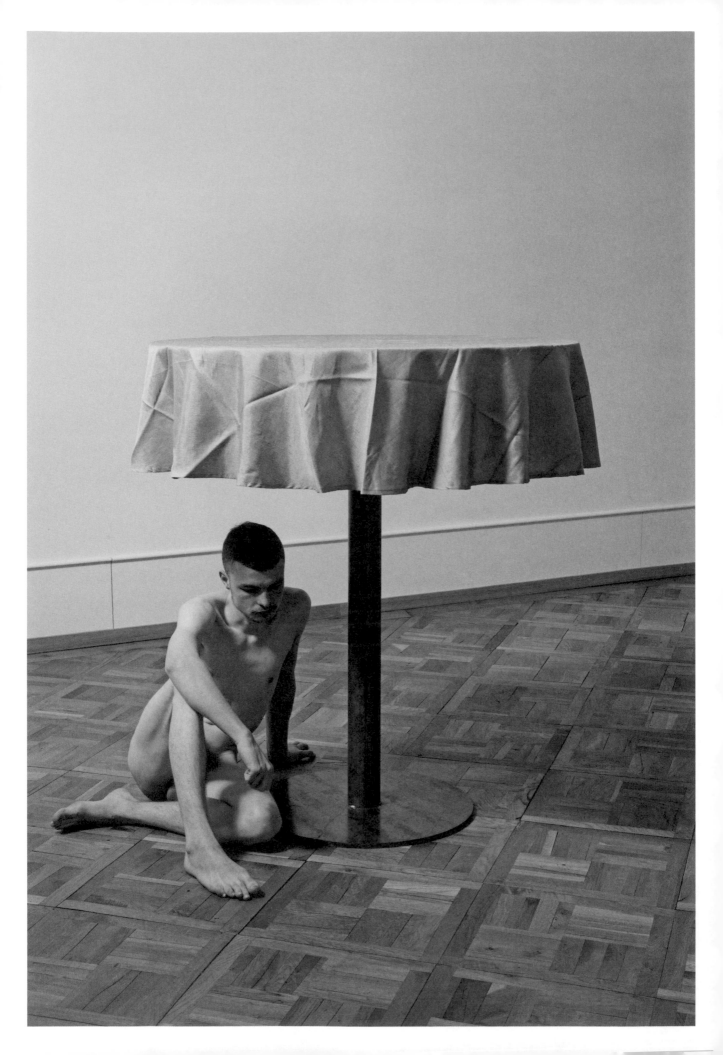

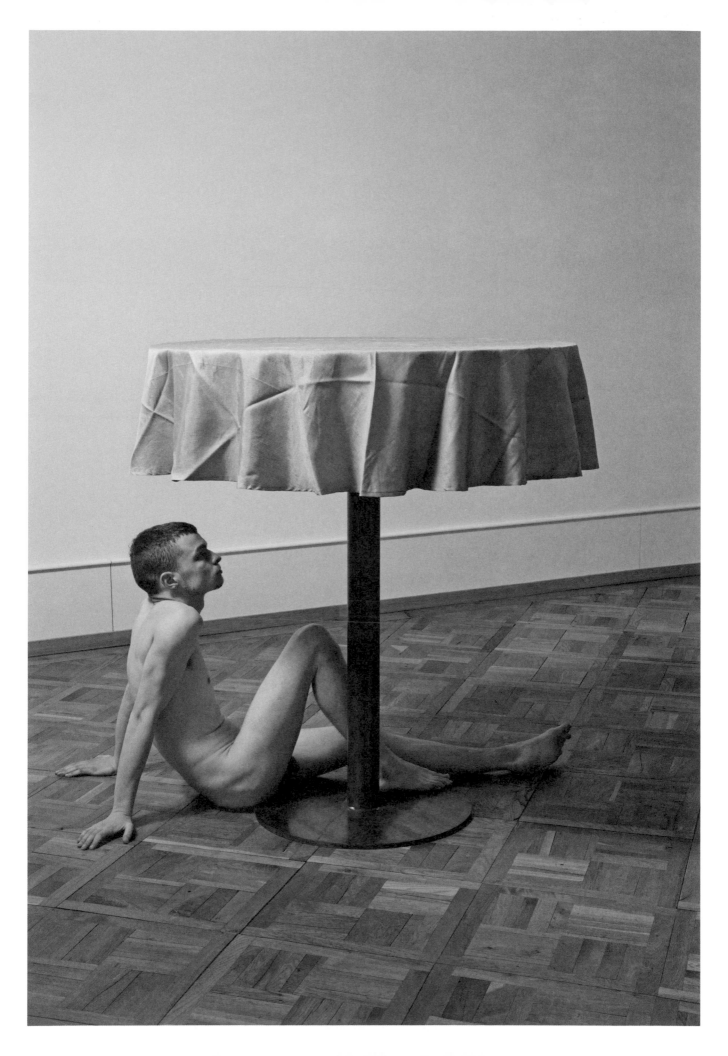

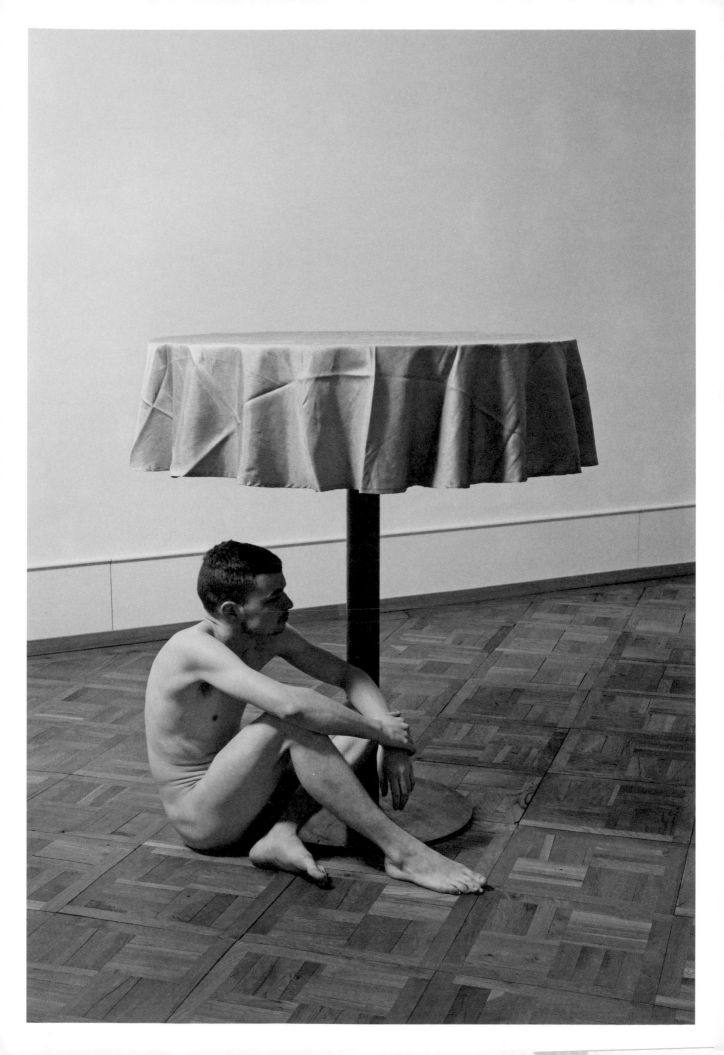

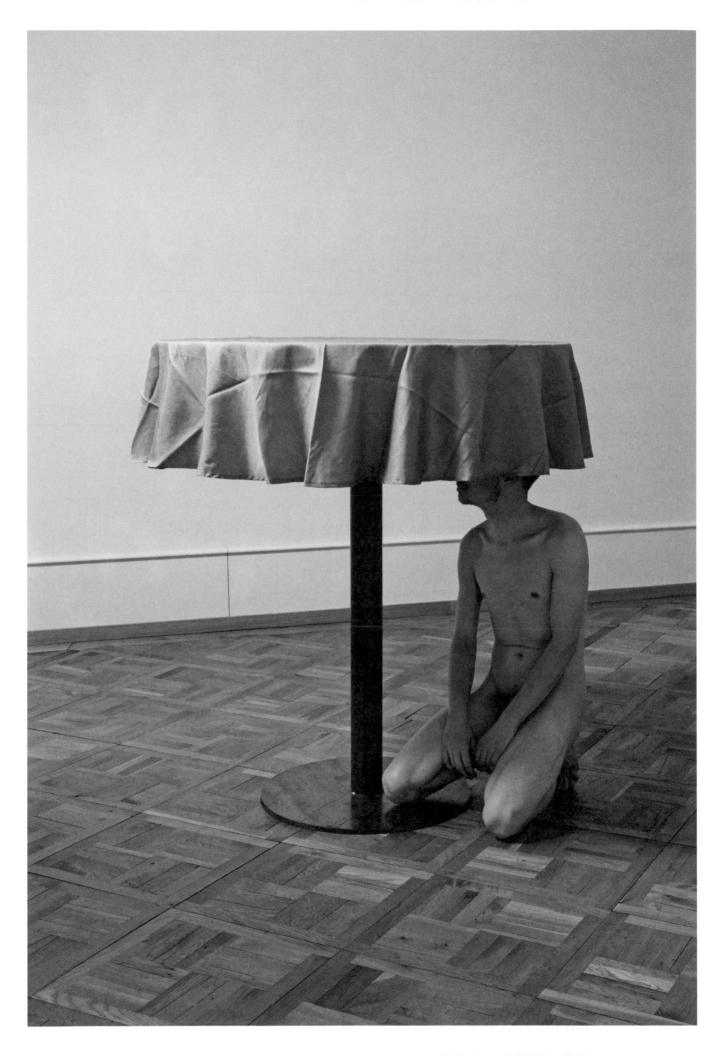

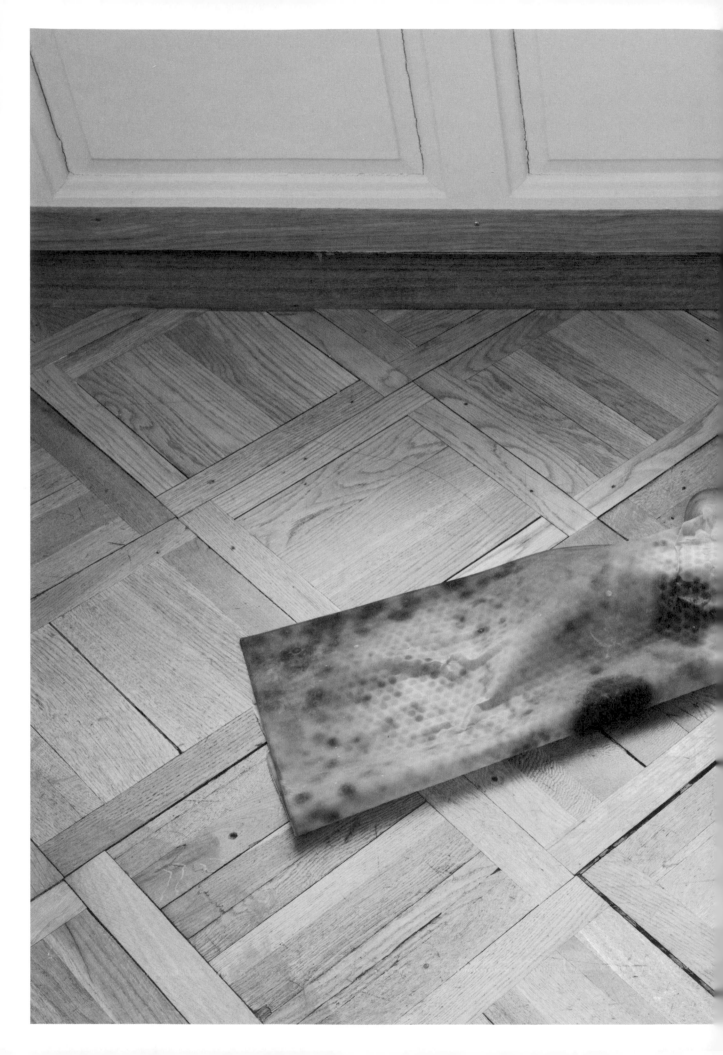

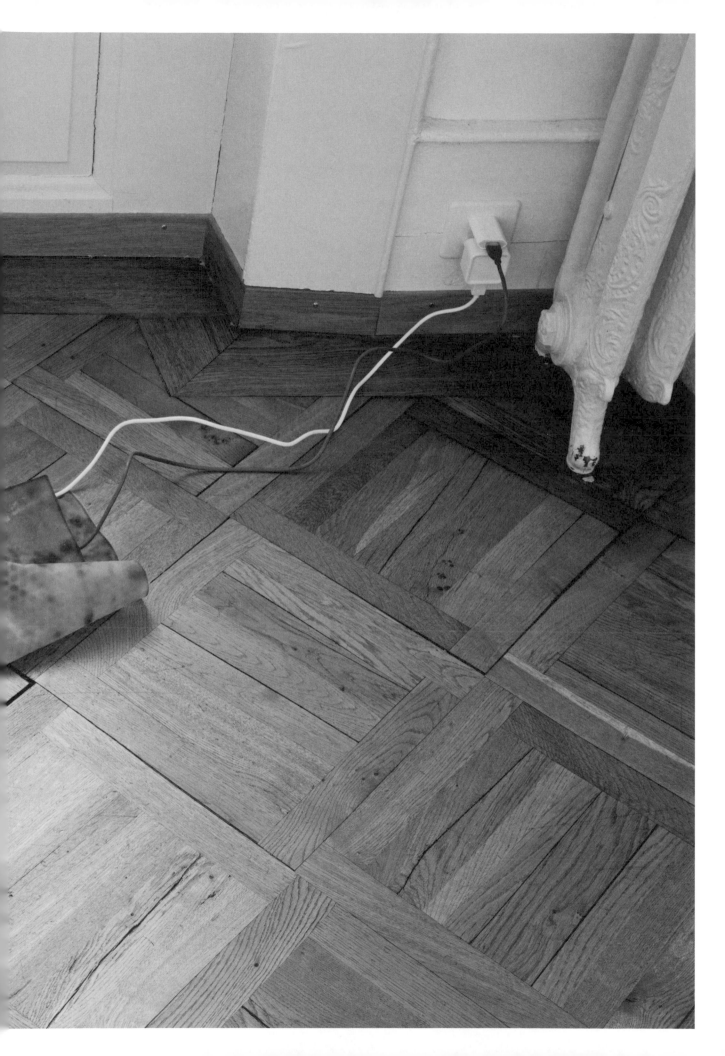

BAKEWELL: The moment every family dreads: Ahmed Khan is 75 years old and failing ... and he's a devout Muslim: what happens when medical judgement is at odds with religious conviction?

Welcome to Inside the Ethics Committee. Here is Mr Khan's son, Ali:

ALI KHAN: It was early morning, my father woke me up and he said — I'm finding it hard to breathe — because he's got a medical condition of the heart we called the ambulance just to make sure.

BAKEWELL: Seventy-five-year old Mr Khan is brought into A and E: it's serious. He's had a heart attack and although his heart's still pumping there's an acute blockage of his coronary arteries. Things move fast: by lunchtime he's taken for emergency surgery, from there he goes into intensive care with multi-organ failure.

ALI KHAN: He was unconscious, he had lots of wires and so he looked very different. It was very difficult for myself and the rest of the family to see him in that state, we'd never seen him like that.

BAKEWELL: Mr Khan's consultant.

CONSULTANT: He was critically ill, requiring a lot of drugs to support the heart, circulation, dialysis which supports the kidneys when they're not functioning and sedation and mechanical ventilation to support his breathing.

ALI KHAN: The doctors mentioned that the next 24 to 48 hours are very critical. Obviously everything else rests in God's hands.

BAKEWELL: Doctors expect that a man of Mr Khan's age who's undergone this emergency heart surgery will need some 10 days in intensive care. But despite signs of improvement, after three weeks he is still very weak.

CONSULTANT: His kidneys didn't work very well. He also had repeated infections and was unable to breathe for himself, requiring continued support by our mechanical ventilators.

BAKEWELL: The matron in intensive care.

MATRON: When someone's on a ventilator for a week or two weeks it can take some time to build up the respiratory muscles because they become very weak very quickly. In Mr Khan's case his weakness was a lot worse, so he didn't bounce back as quickly as we expected.

BAKEWELL: More weeks go by and progress is slow. But there are hopeful signs - Mr Khan is able to communicate with his family.

ALI KHAN: He was awake, he was sitting up, he wasn't able to eat or drink but he was able to see and acknowledge us which was quite pleasing.

BAKEWELL: Even so his family can tell that several weeks in intensive care is taking its toll.

ALI KHAN: He needed quite a bit of physiotherapy, he was unable to stand, there was a lot of muscle mass that he had lost and whenever I spoke to him he was always like I want to go home. And so we were always trying to reassure him that you're getting better and hopefully soon.

BAKEWELL: Then, after two months in intensive care, Mr Khan starts to show significant signs of improvement.

MATRON: He went from being very dependent on the ventilator to breathing on his own without any support at all very, very quickly. He also no longer required the dialysis machine or the drugs to support his heart. And we managed to get him to a ward.

BAKEWELL: But disappointingly the improvement is short-lived. Such a long stay in intensive care has weakened the body's organs. Mr Khan develops a lung infection and his kidneys fail. Only 10 days after leaving intensive care he is back there, with drips and machines and medication keeping him alive.

ALI KHAN: It was definitely a disappointment for everyone really, we saw such a big improvement and that one set back brought him back quite a bit.

BAKEWELL: The consultant again.

CONSULTANT: We had hoped he wasn't going to be readmitted but we resolved that hopefully with a brief bit of treatment, we could optimise his condition and get him back quickly to where he was before.

ALI KHAN: And so we took it day by day and as it went on he started improving again, we were enjoying the time that we spent together. He used to listen to the Koran, so he used to play that and that was quite soothing for him.

BAKEWELL: But Mr Khan's health problems persist. There are periods of improvement then periods of deterioration when his organs require more support. He is very weak and withdrawn. What everyone had hoped would be just a brief stay in intensive care turns once again into weeks, and then months.

MATRON: As his stay became more and more protracted the feeling was that he probably wasn't going to survive this, even taking away very small amounts of support from the kidney machine or from the breathing machine he found it very difficult to cope with that. And we felt that we got to a point where we couldn't make any further improvements.

BAKEWELL: But very slowly, Mr Khan does start to improve. Gradually he can breathe independently and no longer needs support for his kidneys or his heart. However by now, after a total of five months in intensive care his body is severely wasted and he needs round the clock nursing. The team arrange for an intensive care nurse to go on the ward with him: the hope is that she'll only be needed for a week or two. But again hopes are dashed. The moment this intensive care nursing is scaled back, Mr Khan deteriorates. Within three weeks on the ward, he develops another lung infection and once again his kidneys begin to fail.

CONSULTANT: We started to have a discussion about whether we should readmit him into intensive care given his very long stays previously and the actual realistic chances of him leaving intensive care again. A few

82 INSIDE THE ETHICS COMMITTEE: END OF LIFE AND ISLAM

colleagues had mixed opinions, some felt that we shouldn't readmit him, and other colleagues felt well he's made it so far probably we should readmit him. But we hadn't really reached a firm consensus on this.

BAKEWELL: By now, Mr Khan has spent five months in intensive care — this second attempt to keep him on the ward - and out of intensive care - has again failed.

So let's now consider his situation with two of our expert panel. They are:

Dr Andrew Hartle, Consultant in Critical Care and former chair of the Ethics Committee at Imperial College Healthcare NHS Trust and Ayesha Ahmed from the Ethics Committee at Great Ormond Street Hospital who focuses on religion and culture.

So the team are not sure about whether to readmit Mr Khan into intensive care. Now why would they be in two minds about that Andrew?

HARTLE: It's important to remember what intensive care is there to do. It's there to keep people alive long enough to get better, it keeps a patient alive long enough for a treatment to work and that patient's got to have the physical strength and reserve to recover.

BAKEWELL: But we all feel don't we, that intensive care is the best treatment that you can get, so why not keep trying it?

HARTLE: Because ultimately it's not going to work. When you admit someone to intensive care you've got to decide what am I trying to achieve. If you're trying to achieve just delaying someone's dying or keeping their heart beating then almost everybody would be readmitted to intensive care. But if instead you've got a definite goal that you want to make somebody better than they are, that they will recover and how much recovery you expect that's when it becomes much more difficult.

BAKEWELL: Ayesha, what do you make of this dilemma? It seems to me that speaking as it were from a family point of view you look to intensive care as your perpetual last hope, is that

wrong, are we looking for miracles to happen?

AHMED: I do not think it's wrong, I think part of the medical culture in our contemporary society we have the very strong embedded notions about the successes with medicine now and it does seem sometimes that miracles can occur. So I don't think it's wrong that the perceptions that the family can have in this case can easily be traced.

BAKEWELL: So families can be overoptimistic can they, Andrew?

HARTLE: They can. It's also important to remember that intensive care isn't a neutral act at all, almost everything we do carries significant harms as well as benefits. So, for example, if someone isn't able to breathe for themselves we can connect them to a ventilator but that very act of ventilation damages lungs — the breathing tubes, the big drips we put in bypass all the body's natural immune defences which makes further infections much, much more likely. So when we're making the decision about whether the benefits of intensive care are outweighed by the harms we've got to consider we actually might make somebody worse.

BAKEWELL: Well let's consider Mr Khan's situation because the team expected him to be in intensive care for about 10 days, he's obviously stayed much longer. Now does this indicate that he's dying, Ayesha?

AHMED: It is very difficult to decide when somebody is dying. Dying can be interpreted in very many different ways — a biological way of dying, or a spiritual form of dying. The family and the doctors may have different ideas about what dying means. And also a little bit of benefit might be interpreted as more of a sign of hope than the doctors might actually believe it to be.

BAKEWELL: So how does the medical team know if someone is dying? Andrew Hartle.

HARTLE: Well sometimes it's very obvious, if someone is acutely dying and their heart starts failing and their lungs are failing and they're no longer responding to treatment. But sadly in cases like Mr Khan's, so people with pro-

longed intensive care stays, recognising a point when someone stops getting better can be quite difficult to identify and sometimes we only identify it with hindsight.

BAKEWELL: Well let's continue with the story then.

It's spring the following year. Mr Khan is on a ward having spent six months in hospital — five of those in intensive care. He develops another lung infection and the team consider whether to readmit him there for a third time. He's not critically unwell. A short stay in intensive care could be all he needs. The matron.

MATRON: Much as there were discussions initially about whether or not we should readmit him to the intensive care unit it was felt that possibly a few days of intensive therapy might just improve his position so that we could get him back to the ward and he could carry on with his rehabilitation.

BAKEWELL: But things don't go according to plan. After a few days Mr Khan starts to deteriorate dramatically and he's in multi-organ failure again. He is sedated, and put back on the machines that support his organs.

CONSULTANT: You can have one relapse back into intensive care but when you have a second relapse and the same problems have occurred and you can have almost no muscle left in your body, so you can't breathe and you can't support yourself, I think that's when doctors feel that there is very little chance of recovery.

BAKEWELL: The doctor talks to Mr Khan's relatives.

CONSULTANT: We started to discuss with the family whether we should consider limiting treatment, maybe withholding organ support in the face of deterioration in future. This might involve dialysis for the kidneys or possibly ventilation or in extreme cases, if he were to have a cardio respiratory arrest, we would then not actively resuscitate him.

ALI KHAN: Obviously for the family that was very difficult — it's happened in the past, his kidneys have come back and there are signs of hope because he's always shown us.

BAKEWELL: And this optimism is deeply rooted in the fact that Mr Khan and his family are Muslims.

ALI KHAN: The religious point of view of my father and the rest of the family was that we should try and continue treatment as much as possible and preserve life as much as we can and so it was only right that if we had something available to use and leave it in God's hands to see whether it succeeds or fails.

BAKEWELL: A few days after being readmitted the sedatives were stopped. What was Mr Khan's response? It wasn't easy to tell.

MATRON: Mr Khan at this stage was very withdrawn, he seemed very sleepy, his level of communication with the staff and his family had dropped off. It seemed he was depressed. He could hardly move his limbs at all and he was incredibly weak.

CONSULTANT: He was awake some of the time but didn't really appear to be in command of his own consciousness. He would do basic things in terms of command but we didn't think he had any insight into the seriousness of his condition and really where he was and how long he'd be there and how hopeless it all was.

BAKEWELL: The doctor now asks a psychiatrist to assess whether or not Mr Khan is able to make decisions about his treatment for himself. Mr Khan is often drowsy so this takes several visits, and the help of Mr Khan's sons and an interpreter as he reverts to his native tongue — Urdu.

PSYCHIATRIST: We didn't get any verbal communication from Mr Khan, apart from uttering a few words when his communication was at its best. He did try to communicate by writing on one occasion, what appeared to be meaningless lists of members of his family. He knew he was in hospital but he didn't know which hospital, he didn't know which year it was. So he couldn't communicate in a meaningful way, taking into account all the complexities of his medical condition, to give us any meaningful answer about what his wishes would be.

CONSULTANT: When we find a patient doesn't have the capacity to make decisions for himselve really the responsibility then passes to the medical team to decide what's in the best interests of the patient. Obviously any decisions we make are discussed with the family.

BAKEWELL: The medical team are clear that it is in Mr Khan's best interests to limit treatment, but the family still disagree, and they feel they are best placed to judge what their father would want.

ALI KHAN: I can completely understand the doctors' point of view but as a family you know the person more and obviously he's lived his whole life with you and so I think that being so close it should be the family's responsibility to say what should happen. There's a saying [indistinct words] — put your faith in God but tie your camel. So trust in Allah that he will do whatever is destined for you and tying the camel is do everything you can, so whatever was in our means we'd do to try and protect him and trust God to see what he does.

BAKEWELL: The family seeks the advice of an old friend of Mr Khan's, who is also his GP.

FRIEND: I knew Ahmed because he came from the same part of the world which I come from in India, so we were friends for about 30 years. I gave them my opinion as a Muslim and a doctor. My own impression was that God Almighty gave us life. He was a very strong Muslim and he was very strong in his faith. So he would have preferred to have all the treatment continue despite of whether he was going to have an improvement or not.

MATRON: It's not unusual for a family to question decisions made by the medical nursing team in intensive care. It's quite easy to explain things scientifically with numbers — survival rates etc. In Mr Khan's case the problem was the family understood the statistics, they were a very eloquent intelligent family but it wasn't about statistics, it was about the family and their father's belief.

BAKEWELL: But the one limitation of treatment where they do agree concerns the issue of resuscitation.

ALI KHAN: If the heart stopped naturally then it's obviously God's wish. Then it would be acceptable not to intervene in that sort of situation.

BAKEWELL: But Ali and his family struggle to get sound advice on what is in the best interests of Mr Khan — a man who is critically ill but also a devout Muslim.

ALI KHAN: When we spoke to the Islamic scholars we found that there wasn't enough information on when we draw a line on where do we call it a day. I found it quite difficult in terms of getting an accurate answer from someone and so we continued what we felt was the right thing — to continue.

BAKEWELL: Right, now let's return to our expert panel and bring in Mufti Mohammed Zubair Butt. He's an Islamic scholar and hospital chaplain at Leeds Teaching Hospitals.

Zubair, what are Islamic beliefs concerning the end of life?

BUTT: The Muslim faith would regard death to be an inevitable event, something that comes at its own appointed time. God he gives us life and it is he who takes life. We have to try and do what is in our power to preserve this life and protect this life. We believe this world to be a place of cause and effect and the son of Mr Khan has quoted as saying of the holy prophet that you tie your camel first and then you put your trust in God. Which is an indication that we are required to adopt means and then have the faith that God creates the result.

BAKEWELL: This is set out in the Koran is it?

BUTT: It's not a verse of the holy Koran but it is an established principle.

BAKEWELL: We've got this concept of tying the camel — which is taking an action yourself — and then trusting in God — so can you explain it in medical terms?

BUTT: Let me just explain the legal terms and then tying that into medical terms. When you adopt a means sometimes the means will be such that the result is definitive — you adopt the means, you definitely get the result. For example,

we have food and fluid, there-fore as a Muslim we would believe that a person cannot desist from food and fluid because that is a mean that always gives a definitive result and it will sustain life. Then we have means that are presumptive, which means that quite often you get the desired outcome but there are many occasions in which that is not achieved. Most medical interventions will fall within this category.

BAKEWELL: Sometimes the treat-ment, the means, does not work — what happens then?

BUTT: Because sometimes it does not work it cannot be man-datory — the prophet, peace be upon him, he encouraged us to take up treatment but it is not mandatory because the end result is not always achieved. And then there is a final cat-egory where an intervention is speculative — there's no real hope of achieving the desired result. In this third cat-egory it is better not to adopt treatment and trust in the will of God.

BAKEWELL: And how does that apply to Mr Khan's case?

BUTT: In Mr Khan's case there was no treatment for his case so therefore to continue to pursue medical intervention was not mandatory. At best it could be speculative.

BAKEWELL: So what you're say-ing is that the Muslim faith, as you define it, supports the doctors' view to limit treat-ment?

BUTT: In this particular case I would say yes. The decision to limit treatment is something that would be taken in conjunc-tion with the family.

BAKEWELL: Ayesha, the family are obviously struggling to do the right thing by their Muslim faith.

AHMED: The important thing here to remember is that although the family are saying when it's God's will my relative will die is that there is a strong emphasis on your own personal responsibility. In the Koran it is taught that for every life that is saved it is as if the whole of mankind has been saved. But if you take away life then it as if you have killed all of mankind. And even

if Mr Khan had the capacity it would be very much a family-orientated decision and that is why they are feeling an extreme burden about how to do the right thing.

BAKEWELL: Yes, it's a heavy, heavy responsibility — the fam-ily must have worried a great deal about that. Do you find that this is true, Zubair?

BUTT: I have many experiences of this type and this issue has appeared in the last few decades. Previous to this when somebody died you responded to the death. Here you are being asked to be passive or be an instrument in an instrument in the death and so it's a dif-ferent paradigm now. There's no legal discussion historically within Islamic sources and so Islamic medical ethics it's something that's an emerging science really.

BAKEWELL: Well you've described very clearly how limiting treatment can be acceptable but the Khan family don't seem to know that.

BUTT: It is quite difficult when a family is faced with a situation like this to have access to the correct and right information. Normally what hap-pens they will resort to their local Imam. Sometimes that Imam may not be qualified to the level that is required.

BAKEWELL: So are there enough people like you?

Butt: Unfortunately no, there are very, very few people who have training in this area from the Muslim faith and so it is not surprising that Mr Khan and his family were unable to find any clear-cut answer in this area.

BAKEWELL: Andrew.

HARTLE: I have to say finding someone with your experience would be enormously helpful. We would all benefit from your help.

BAKEWELL: As a doctor, Andrew, have you been in similar sit-uations with Muslim families yourself?

HARTLE: Yes I have and it's a problem that's not unique to Islam. I've dealt with patients and their families from almost every religion. So, for exam-ple, most of the Jewish faith

have very strong views which are not not dissimilar about the end of life, it's the con-tinuation of the heart beat that is important. And I under-stand that in Israel once the treatment's been instituted there would be considera-ble barriers to withdrawing a treatment, the most well-known example wouldprobably be that of Ariel Sharon who had a stroke many, many years ago and as far as I'm aware con-tinues to be in a persistent vegetative state but is still ventilated and my understanding is that Israel has one of the largest systems of long term ventilation — a practice very different from that in perhaps more Western cultures. And I think one of the challenges for me and my colleagues, I mean although I don't particularly profess any religious faith, I was brought up in this country and I've been exposed my whole life to the teachings of Chris-tianity and so if an Anglican or a Roman Catholic came to me and said my religion says, I'd be probably in a much better position to be able to discuss it with them and perhaps even challenge them and the best example of course is Catholi-cism which draws a very clear distinction between ordinary and extraordinary means and I'm much more familiar with that. It's much more challenging for me than to deal with someone from another faith or another ethnicity. And I think we're always particularly concerned about making assumptions, causing offence and I seek the same advice and guidance as Mr Khan's family do.

BAKEWELL: It's an interesting clash isn't it because medicine deals in mechanics and dying is about more than mechanics, it's about a spiritual experience. So can these be reconciled, Ayesha?

AHMED: I'm hopeful that they can be reconciled. One of the great ironies of modern medi-cine is that it has produced all these precise details about the body but when we have a situation like this medicine is still unable to answer the pre-dominantly metaphysical ques-tions that we've been asking throughout the whole of human existence. So I think medicine is having to become moro famil-iar with this type of existen-tial questioning from all kinds of faiths.

BAKEWELL: Well, let's go on with the story of Mr Khan. Mr Khan has now been in hospital for about seven months - six months in intensive care. He's about a month into his third stay. The team have weaned him off the dialysis supporting his kidneys, but they remain very fragile so could need support again. The doctors maintain it is in Mr Khan's best interest to limit his treatment and let him die a dignified death.

The family continue to disagree.

So the team keep treating him but his body is completely dependent on artificial medical support. They're also aware of the pain this treatment is causing him. The doctor and then the matron.

CONSULTANT: I said to the family that I thought their father was suffering and I told them about how much one can suffer in intensive care.

MATRON: He had very disturbed sleep patterns, every morning it was reported that he hardly slept overnight. He was very wasted, his muscle tone was very poor, his ligaments and tendons in his hands and feet had shrunk, so he didn't have full range of his limbs and he seemed very withdrawn. And all the while we were having to clear his airway with the suction into the lungs every two hours and this is described from patients we've had here in the past like a hot poker being put down into your lungs and is incredibly painful.

BAKEWELL: The family don't doubt that he's suffering but they just see suffering in an entirely different light. His son Ali.

ALI KHAN: We believe that throughout the day we sin and so being unwell, even like a temperature for example, is brought upon by God, we believe that it's wiping off our sins. And so while we feel that obviously with being injected with needles and everything there was always a sign of hope for us. And we always prayed for him and he always bounced back, that was for us enough to say we should try and continue as much as we can, because he's always fought back.

MATRON: As time progressed the nursing staff were more

and more of the belief that he wasn't going to survive and they were putting him through the suffering in some ways with the interventions they were doing and that we could actually give him a dignified death, allow his family to be with him through his last moments of life.

FRIEND: In early stages, when he was conscious, he was still still accepting the needles going through the body and the machines going on, so he was positive that he wanted to get better and he was in no way going to say I would like to end this suffering. In suffering which is happening we think that this is given by the God Almighty to take away all the punishments we are going to face in the hereafter. At a later stage, when he was not so conscious we thought that he would have continued with the same opinion.

BAKEWELL: Mr Khan is now enduring great suffering. A couple of weeks after taking away dialysis, his kidneys are failing again. The doctor sees this as a moment to refrain from restarting kidney support and let Mr Khan die peacefully. He speaks to the family again.

ALI KHAN: We insisted that we would like to continue with the dialysis and the doctors agreed. We prayed quite a lot for my father and he wasn't producing urine for about 20 odd days but then he started producing urine and then slowly the dialysis was taken off.

BAKEWELL: Despite their different points of view the team work hard to keep the family with them.

MATRON: From our point of view there was a patient at the end of this and we still had a very amicable relationship with the family, I think the one thing we did agree was that we didn't want to fall out over this.

BAKEWELL: The medical team recognise that the intensive treatment is artificially prolonging Mr Khan's life. But the family is waiting for God to decide the moment of death. The doctor contacts the clinical ethics committee for their advice.

CHAIR — CLINICAL ETHICS COMMITTEE: There was such a dispute between the clinicians

and the family that it might assist if I was able to facilitate a meeting between the clinicians and the family.

BAKEWELL: The chair of the committee staid neutral, while the family and the medical team each put their case forward.

CHAIR: This took quite a long time but then it became apparent to me that the two sides were, if you like, coming at the issue in very, very different ways and it resulted in me eventually asking the question of the family — are you saying that any life is better than no life? Because it seemed to me the clinicians were approaching this in terms of best interest, which is a matter of weighing up benefits and costs of continued treatment of different sorts, whereas the approach of the family was entirely different from that — it was any life is better than no life, whatever the discomfort there might be. When I asked that question they said yes that's precisely what we're saying. And so that clash of paradigms, if you like, explained the difficulty of the relationship between the clinicians and the family.

BAKEWELL: Now let's have our final discussion on this matter. Andrew Hartle, as a medical man, haven't things gone on long enough and what legal right does a medical team have to override people's religious requests?

HARTLE: The legal position, at least in England and Wales, is established by the Mental Capacity Act 2005 and governs only those circumstances where the patient lacks capacity, as Mr Khan clearly does. And the decision maker in this case is the doctors and in a whole series of legal cases judges have established quite firmly that a court would never require a doctor to do something that that doctor did not think in the patient's best interest.

BAKEWELL: So why isn't this team withdrawing treatment?

HARTLE: Having a patient die is bad enough in intensive care, having a patient die with conflict and unpleasantness between them and the family is something that we want to avoid. We shy away from conflict and I think sometimes we can let it go on too long.

There seems to be no hope here.

BAKEWELL: Andrew, you find yourself sort of at the high end of Western technology, confronted by different cultural tides washing over the decisions you have to make, what does it feel like when these kind of objections are brought to you?

HARTLE: It's dreadful, my heart goes out to all of the doctors and nurses treating Mr Khan. We all went into medicine or nursing to make people better and I suppose deep inside we're afraid — we don't like being criticised, we perhaps don't like not being believed.

BAKEWELL: You don't want to be sued.

HARTLE: Don't want to be sued, we don't like bad publicity, I mean the health service is always under immense scrutiny, no more than at the current time and much of that is justified but there is a part of that which says I'm doing my very best here and yet I run the risk of criticism in the press, in the courts, by ministers, or in the House of Commons.

BAKEWELL: But valuable resources are being expended over a long period of time to satisfy this family. Now is that ever a consideration?

HARTLE: My professional regulator, the General Medical Council, would tell me to say that it should never be an issue. But the National Health Service, like any health system, does not have an unlimited pot and whilst we haven't discussed futility as an ethical concept there is certainly a part of the discussion of futility about economic futility. Can I actually achieve my goal and afford it. And I think somebody who's been in hospital and intensive care for the best part of six months and we are talking about the most expensive part of hospital medicine, thousands of pounds a day.

BAKEWELL: Ayesha, what do you make of this issue of resources?

AHMED: It's a huge issue, also it is not incompatible with trying to mediate it with some of the religious concerns that have been put forward here. Within the context of Islam there are strong arguments in terms of even though every individual life has an absolute value and is sacred public interest must also be taken into account and it can at times override an individual's interest. So here again there is scope for dialogue.

BAKEWELL: But in cultures generally is there ever a suspicion by patients that the medical team would just want out?

AHMED: I think this is a very accurate description of what maybe this family or many of the families might experience. One of the unspoken issues is about trust. In some societies, for example, family members are used to having to bribe the doctors to perform certain treatments and surgery, otherwise their relative would just be left to die. The other alternative for Mr Khan is palliative care. But in a society where palliative care is not developed there is no concept of what this means as opposed to active treatment for that patient.

BAKEWELL: Do families ever suspect that financial matters come into it? Andrew.

HARTLE: Yes they do.

BAKEWELL: Do they say so?

HARTLE: Very rarely. When I've been accused, and I have been accused of wanting to stop care because I didn't want to spend money, it's often been in the acute setting. I think after six months there could be no question that money wasn't the issue.

BAKEWELL: Couldn't this be resolved in the courts, Andrew?

HARTLE: Well ultimately yes but going to court is enormously expensive and of course all the time that doctors and nurses are tied up developing a legal case they're not actually doing their main job.

BAKEWELL: Let's raise this issue of suffering. Mufti Zubair Butt, what is the Islamic view of suffering?

BUTT: When suffering is in the pursuant of something that is an obligation or you are highly recommended to do or you are unable to avoid then that is rewarded.

BAKEWELL: So suffering earns you a reward ...?

BUTT: It does earn you a reward ...

BAKEWELL: In life after death?

BUTT: There is an expiration of sins.

BAKEWELL: What about Mr Khan?

BUTT: Mr Khan's situation is such that he is untreatable. There is and this question here of distributive justice where we are using the resources for Mr Khan where they could be better used elsewhere and we are not going to get an improvement here. So for me the argument by the family that we are being rewarded in this may not possibly hold true in its entirety.

BAKEWELL: Ayesha.

AHMED: For the suffering one of the reasons it's so significant in not just Islam but other religions as well is that it attunes you to your spiritual side, to the side that exists beyond your earthly existence. And in Islam it can also show that you accept tests from God in terms of your endurance. But there is a difference between suffering that arises from God and a suffering that is inflicted on somebody and this is where you could make that distinctive in Mr Khan's setting. So suffering from his multi-organ failure is a different kind of suffering from interventions like inserting the ventilator.

BAKEWELL: Andrew, the idea of suffering is at the basis of many religions and is seen as a way of earning your rewards in the eyes of your creator — how do you react to that?

HARTLE: It's not a concept I subscribe to but in the circumstances of Mr Khan it strikes me that we've moved beyond what is a reasonable expectation, almost that as a doctor I'm making somebody suffer for an artificially prolonged period and nothing else, no relief to that suffering other than by death.

BAKEWELL: Ayesha, this man, Mr Khan, is now clearly dying. Is the moment coming when God has designated his death and is that clear to Muslims?

AHMED: I think the family are becoming aware that the moment of the death is arriving. I do not think that they've been in denial of Mr Khan's death, they have been afraid of creating a situation in which a premature death might occur. So I think Mr Khan's family are realising now that this is actually the right time.

BAKEWELL: Let me put this to you all — is a life sustained by machines a life? Because presumably machinery now could keep a body going for years — is that a life that you're saving?

BUTT: For Muslims the point of death would be when the soul departs from the body. And it is possible that that soul has departed and the body's still artificially kept functioning.

BAKEWELL: How can you know?

BUTT: If I knew that I would be a very rich man.

BAKEWELL: Ayesha, what do you make of this conflict between medicine, which is continually able to prolong life by mechanical means, and this sense that life has a trajectory which should naturally come to an end?

AHMED: Death used to be one of the greatest certainties we had in life but now medicine has created a huge ambiguity around when does the person die and it's a question for all members of religious faiths.

BAKEWELL: And for all doctors. Andrew.

HARTLE: This is true and although we're talking about this as if it's an issue of faith it's only an issue of faith for a relatively small part of the world's population. For the vast majority of Muslims and probably Christians all over the world we wouldn't be having these discussions because the resources of modern medicine would not be available to them.

BAKEWELL: Right, let's imagine that you are on the ethics committee, let me ask each of you what you would advise. Andrew Hartle.

HARTLE: I would no longer escalate care. I would not introduce any new treatments, I would not increase any existing treatments, I would change the emphasis of my care entirely to making sure that Mr Khan is comfortable and is not suffering but at the same time I would continue my dialogue with the family.

BAKEWELL: But suppose the family continues to ask you to intervene, you would refuse their request?

HARTLE: Yes I would.

BAKEWELL: Zubair, what would your advice be?

BUTT: My advice would be ensuring that the family had access to correct information. Secondly, as mentioned previously by myself, it means that a definitive would have to be continued, that would include food and nutrition, similarly the antibiotics would have to be continued because the effect of that is definitive. However, further treatment of Mr Khan I would not advise.

BAKEWELL: Ayesha.

AHMED: In this situation I would advocate that a limiting of treatment is advised. I think this is very compatible with their religious views but I would find it difficult to advise against artificial hydration and nutrition and also the limiting of antibiotics — I think that can be problematic.

BAKEWELL: Thank you all. So let's hear what actually happened to Mr Khan.

The clinical ethics committee advises the medical team to decide within two weeks — either to limit his treatment or to go to court to decide.

CHAIR: The clash of paradigms in this case was so profound that it seemed to me that a decision should be taken as to whether this case did need to go to court within two weeks. I also said within the meeting that I thought it wasn't helpful that the current situation should continue in a chronic fashion, as perhaps it had already continued.

BAKEWELL: On a practical level, this is difficult for the team.

CONSULTANT: That time was quite difficult in intensive care and there was some disagreement amongst my colleagues over the course of action we should take. Some felt we had autonomy as physicians and we should make the decisions.

BAKEWELL: They were also wary of the possible consequences of limiting Mr Khan's treatment.

CONSULTANT: The family could have possibly complained to the GMC that we had acted against their wishes or we had committed manslaughter or … so this was a personal concern to all of us.

BAKEWELL: On the other hand, they were also reluctant to ask a judge to decide.

CONSULTANT: I didn't want to go to court because I think that's always difficult and the family would have to live with the legacy of what had happened and possible bad feeling resulting and I didn't really want to impose that on them. I tried to balance these points of view and to maintain a line of communication with the family.

BAKEWELL: There are still times when Mr Khan rallies. Each step forward is followed by two steps back. Meanwhile the two week deadline for action recommended by the ethics committee passes, and the weeks again turn into months.

Mr Khan's condition deteriorates further. He is bleeding in his intestines, his weakened immune system leaves him open to repeated infections, both his heart and lungs continue to fail - all of which the medical team actively treat to keep Mr Khan alive.

ALI KHAN: There was a lot of medical conditions that were going on — obviously breathing was the primary problem that he had, the heart was weak, he was passing up blood. Generally speaking there was multi-organ failure. And the doctors obviously said to us look we're struggling.

MATRON: He became increasingly difficult to manage and from a nursing point of view the team felt that at this point we were really putting him through a lot of suffering when it was needless to a point and some people didn't want to look after him because of that.

BAKEWELL: Mr Khan eventually stops responding to his family.

ALI KHAN: He started dete-
riorating again and then he
started vomiting as well.
Breathing became difficult
again, despite being on the
ventilator. It was destined
to happen at that time. And
unfortunately he passed away.

CONSULTANT: Mr Khan suffered
a very short onset of cardiac
arrest, deteriorated dramati-
cally and we then respected the
decision we had made not
to resuscitate him from this.

FRIEND: As a Muslim we have a
firm faith that God Almighty
has made the heart to pump up
to a certain time. So a time
came to the exact second when
all the system failed in spite
of continuation of everything.
So the time of his death is
fixed at exactly the time which
is intended by God Almighty —
this is our firm belief.

BAKEWELL: Mr Khan died last
summer. His third and final
stay in intensive care lasted
over five months. So in total -
10 months in hospital, nine of
which were in intensive care…to
spell it out, that's 279 days.

CONSULTANT: I think without our
medical interventions Mr Khan
would have undoubtedly died a
long time before. We have had
patients who've stayed up to
a year with us and like Mr Khan
we would probably have lim-
ited the treatment of all of
these patients but for family
objections. The expectation
now is that medicine can always
deliver almost eternal life
and I think to a large extent
people deny that we have to
die, the expectation now is
that medicine can always make
people better.

ENDS

The Panel Professor Gareth Evans is Consultant in Medical Genetics at Central Manchester University Hospitals NHS Foundation Trust.

Deborah Bowman, Professor of Ethics and Law at St George's University of London.

Richard Ashcroft, Professor of Bioethics at Queen Mary University of London.

I am listening to your very interesting programme about genetic testing - but I must correct an error by one of the speakers. She said that Huntington's Disease does not develop in juveniles - and this is completely wrong. Please see the website of the Huntington's Disease Association and ensure your speaker is corrected and, if possible, a correction is broadcast. I am copying our regional RCA for info.(Sue Fortescue) — It has just been stated by one of your experts that children cannot get Huntington's Disease as a child as it only develops in one's 30s and 40s. This is not true. There is Juvenile HD and a child can start JHD as young as a baby. I have worked professionally with one such sufferer who was diagnosed at 10 years. There is a JHD organisation. Please correct this error. (Hilary Allanson)

BAKEWELL: Developments in genetics bring blessings but also dilemmas. Knowing more about our genes can present parents with a problem — if they carry a faulty gene should they test their children? Welcome to Inside the Ethics Committee. Alan was in his late 30s when he and his wife Rachel received some terrible news.

RACHEL: I remember sitting in the room, it was a tiny little room, there was a MacMillan nurse but at first we didn't know who she was.

BAKEWELL: Due to the sensitive nature of their story, Rachel's words have been re-voiced by an actor.

RACHEL: The doctor was in front of us and he was explaining to us in a long roundabout way before he said the words 'lung cancer'. Obviously I was trying to be positive but my face must've said it all really. My husband just hung his head low and he looked really shocked and the doctor was explaining that he would need to start chemotherapy. The doctor was asking us how we felt and what we thought, and at the time we just couldn't really answer, we were just so stunned.

BAKEWELL: Alan goes into hospital for the weekend for his chemotherapy then he's sent home for three weeks recovery, then back in for the next lot and so on — to and fro for several months.

RACHEL: The first couple of sessions he was ok, he wasn't too bad. And then the sickness was coming in. He came home after having the infusion and he wanted a bath. Luckily the children were in bed and he shouted down to me and I went running up and all his hair started to come out. The kids were a bit shocked the next day because the night before their dad had hair and the following day he had none (laughs). He'd also started to lose a bit of weight, his skin was starting to go a bit translucent, that grey sort of look.

BAKEWELL: Alan's siblings are also worried about him. He has six brothers and sisters.

RACHEL: When he had the lung cancer we first thought that it was just lung cancer. But then we realised that the problem he went in for in the first place was the lump in his arm, and also talking to a family member, he had kind of put the idea that there could be something linked to the family, a gene possibly that might be involved. My husband's brother had said to us that in the past he'd had a tumour and that he was going to have a blood test for a gene. So his brother got tested and found out that he had this gene.

BAKEWELL: The gene Rachel is talking about it TP53 and a fault in this gene causes Li Fraumeni Syndrome. Consultant in genetics Helen Hansen.

HANSEN: Li Fraumeni is a condition which causes an increased susceptibility to cancer. The cancers can affect any part of the body. The most common cancers are those affecting the breast and the brain, but the cancers can also affect soft tissues of the body such as muscle, blood vessels, nerves, the bone.

BAKEWELL: The gene involved - TP53 - is known as the guardian of the genome because it puts a break on cancerous tumours developing. So a fault in this gene releases that break allowing cancers to develop. And the chance of this happening is high.

HANSEN: The figures that are most widely quoted are about a 20% risk of cancer in childhood, about a 50% risk of cancer by the age of 50 years and about a 90% chance of cancer by the age of 70.

BAKEWELL: Simply knowing about this condition has Alan and Rachel worried.

RACHEL: During that time another of Alan's siblings was unwell and had to go into hospital and they found again that there was a tumour. That kind of started the ball rolling from the genetics side because - well my husband's from a large family we were like — it's like several siblings that are now being affected. What would we do if Alan had it? And the possibility that he could, was kind of getting to be higher and higher more than him not. Alan is getting worse. He is very weak and has to keep going back to the hospital with various infections. All the while they are trying to keep family life going. They decide to get Alan tested. To their horror, he also has the faulty gene.

RACHEL: It was kind of a sombre mood. We didn't know much about it and what the future was holding for us. We kind of brushed it under the carpet a bit because we were dealing with Alan's cancer, we wanted to concentrate on getting him through the next few months.

BAKEWELL: Then Rachel and Alan have some unexpected news - Rachel is pregnant.

RACHEL: Obviously my first thought was how could this happen because the doctor had said that we may not be able to have more children because of the chemotherapy that Alan was having. So I was in denial. I

wasn't happy about being pregnant but Alan loved the idea of it and he was like 'the more the merrier', despite what he was going through.

BAKEWELL: As Alan has Li Fraumeni Syndrome, there is a 50/50 chance that his unborn child could have it too. Prenatal testing can confirm whether or not the baby has inherited the same condition.

HANSEN: This is normally performed at around 12 weeks of pregnancy where a needle is inserted into the placenta and the cells are then tested for the genetic mutation in the family. This will then tell us if the baby has inherited the condition from the parents.

BAKEWELL: Let's now discuss this story so far with our panel of experts. They are:

Deborah Bowman, professor of ethics and law at St George's University of London; Professor Gareth Evans, consultant in medical genetics at Central Manchester University Hospitals and Richard Ashcroft, professor of bioethics at Queen Marry University of London. Well we learn more and more about genes behind certain illnesses so is this genetic problem generally cropping up more and more, Gareth?

EVANS: Well I don't think inherited cancer is necessarily any more common, it's just we're better at recognising it. So more and more genes are being identified which are being linked with a high risk of cancer. For instance one in 20 women who get breast cancer have inherited a fault in a high risk gene — we've heard about BRCA1 with Angelina Jolie recently and TP53 is a very rare cause of a very high risk of cancer. So it's going to be a relatively uncommon situation but as more and more people are tested we are going to get more and more families who are faced with these sorts of dilemmas.

BAKEWELL: Right, you mentioned testing, well we've heard that prenatal testing for Li Fraumeni Syndrome is available in pregnancy, is this offered to all women who might be carrying an affected child?

EVANS: It should be part of the discussion with any family where an individual has been found to have a mutation in

TP53. Generally there has to be a perception that they are at least considering not going through with the pregnancy. The reason for not allowing prenatal testing just for curiosity is that you will be taking away the autonomy of that child when they're born to have any part in the decision making for themselves.

BAKEWELL: Deborah Bowman, what do you make of the ethics of this situation?

BOWMAN: I accept what Gareth said but I think there are other valid reasons for having the information. So it might be about managing uncertainty within a family in a particular way, it might be about preparation. So I guess for me it may not be the only way of looking at this knowledge and I think it presupposes that we can prospectively know how we'd respond and that in and of itself is complex and difficult.

BAKEWELL: Richard Ashcroft, what do you make of this in terms of bioethics?

ASHCROFT: One thing that we now are able to do is test where we have a reason to worry. But what's beginning to emerge already is where people are having panels of tests before or during pregnancy to enquire as to what sometimes people refer to as a future diary of their child's life. So where people are starting to say well I want to know whether my baby is going to be healthy in a more general way, a sort of curiosity about their child's genome, this will get more and more challenging for people.

BAKEWELL: And your response to that is that we need to put some limits on this otherwise it becomes completely surreal and futuristic, doesn't it?

ASHCROFT: Yes my natural response to most things of this kind is caution but I recall about 10 years ago there was a genetics white paper from the Department of Health which suggested full genome testing for all newborn babies. I don't know where that came from and it disappeared rather quickly but it was definitely in there.

BAKEWELL: Well that's for the future. Let's stay with this story because Gareth, you've spoken of the testing in

pregnancy but there is another way of testing for the gene, isn't there?

EVANS: There is the possibility of pre-implantation genetic diagnosis which is having embryos created outside the womb by IVF treatment and then when the embryo grows to the eight cell stage, so eight building blocks of the new embryo, you can then take one of those cells away and test it specifically for the gene fault that you know in that family. And then you would only implant embryos that didn't carry that genetic fault.

BAKEWELL: So let's resume the story. Rachel is in the early stages of pregnancy. While Alan knows he has Li Fraumeni Syndrome, he and Rachel aren't offered a prenatal test that would tell them whether their baby inherited it too. Alan is still having treatment for his lung cancer and there are complications — a collapsed lung. He has an operation to remove part of it. Back home he and Rachel struggle to resume their family life. As well as expecting a baby, they have three other children. But the months that follow are bleak. One of Alan's siblings dies of cancer, and Alan is getting increasingly unwell. Soon he's readmitted to hospital.

RACHEL: The next day I spoke to him on the phone. He was a bit tired and I asked him if he wanted to speak to the children. He said no, he didn't want to at that time but to send them his love. And then the following day, I rang him. He sounded really out of breath, uncomfortable, you could hear it in his voice. I asked him if he was ok and he said no, he said things aren't happening the way they should, he said I don't feel so good. Rachel rings her parents to look after the children and rushes to the hospital.

RACHEL: I took my dad with me and a couple of Alan's siblings and we went up and saw him. And he was sitting up in bed laughing and joking, he had trouble breathing, his face was pale white, his feet were ice cold. He just didn't look right. So we were genuinely trying to keep his spirits up.

BAKEWELL: During the night Alan is moved to intensive care. He dies the next day.

RACHEL: I sat in the car on the way home in total shock. How did this happen? And then the feeling of numbness was taking over. I got home. The children were still awake and then I broke the news to them. We got the funeral over and done with and there were issues with the children - some needed counselling, some were too young to have the counselling. But we were slowly getting our lives back together. Alan would've been 40 the year that he died so we marked that by having a barbeque in the garden, we sent Chinese lanterns up into the air, and I got a plaque made for where his ashes would go which is our local church. And the children did so much with the church and the school that we thought it'd be nice.

BAKEWELL: Soon after Alan's death, Rachel gives birth to their baby. Now with four children to look after, she's on her own coping with family life. It's proving tough. Over the coming months the faulty gene causes further devastation within Alan's extended family.

RACHEL: A few of Alan's siblings got tested and they were positive. A second sibling had died and some of the others were starting to develop the cancers and the gene was starting to affect the children in Alan's family, you know, grandchildren, nieces, nephews. And because some of my kids are around that age, alarm bells started to ring, I mean this is obviously quite an aggressive gene. So thoughts of 'what do I do with my own kids?' sprung to mind 'do I get them tested, or do I leave it and let life carry on as normal?'

GENETICS COUNSELLOR: I was asked to meet Rachel to offer her some support after the death of her husband Alan.

BAKEWELL: The genetics counsellor.

GENETICS COUNSELLOR: She was very concerned obviously for the wellbeing of the children, whether there was anything she needed to watch out for with regards to the children's own health. She'd expressed some interest in thinking about when would be the appropriate time to offer testing.

RACHEL: What convinced me was that this gene can develop cancers in children. The more

I looked into it, there was a high chance that my kids could have it. I felt the more knowledge I was armed with, well that would help later on.

BAKEWELL: Is there a benefit to knowing if a child is affected? Rachel is acutely aware that if any of her children have the faulty gene there's a high chance they could become ill in childhood. The consultant in genetics again.

HANSEN: The cancers can occur at any point throughout childhood. It can be seen in very young children or it can be seen throughout the teenage years. It's very hard to give a defined risk for a particular age-group, but overall it's about 20% in childhood.

GENETICS COUNSELLOR: Rachel's hope was that testing would indicate to her which of the children she would need to worry about and march off to the GP quite promptly and which children wouldn't be at increased risk and say 'well that's just a tummy ache, headache', and perhaps lighten her load as a very busy single parent.

BAKEWELL: Despite the risk of cancer developing in childhood, these cancers can't be detected early so it could be argued that there is little benefit in testing children while they're young.

HANSEN: The main purpose of screening is to detect cancers in an early stage so we can influence survival from that cancer. But for children affected with Li Fraumeni Syndrome, the cancers can affect multiple sites within the body and there is no proven screening measurements known to be of benefit.

BAKEWELL: For this reason, testing for Li Fraumeni Syndrome in young children is not recommended.

GENETIC COUNSELLOR: Some of the concern is that by offering a test you then leave that individual with the burden of knowing that they have this condition but that actually the health service doesn't have anything to offer. So we go back then to whether the child could make a decision about having a test maybe at an older age so that they know that then

screening would be available within a reasonable time frame.

BAKEWELL: In adulthood, of those who are affected, women are offered breast cancer screening from the age of 20. For men there is no screening. So parents who want a child tested are usually encouraged to wait.

HANSEN: If we were considering testing a child then ideally we'd want to be acting in the best interests of a child and ideally we would like them to be involved in the discussions that take place. We would consider waiting until a child was older, so in their late teenage years, to offer testing but people may defer testing until adulthood.

BAKEWELL: Interestingly, when given the choice of testing or not more than half of adults at risk of Li Fraumeni Syndrome decide not to have the test. So it's possible that some of Rachel's children will feel the same.

GENETIC COUNSELLOR: Once you've had a test result you can't remove that test result and for children one of the issues is their right to know versus their right not to know. But Rachel is finding the uncertainty of not knowing increasingly difficult.

RACHEL: At first I was sort of a bit like 'you know, this is my family, surely I can do what I like to a point?' But then I thought well, I don't know, maybe she is right because I am taking their right away.

BAKEWELL: But, on balance, Rachel feels the benefits of knowing outweigh the risks.

RACHEL: I felt that I could protect my children by being forewarned about what this gene could do. And the more I looked into the gene I started thinking, yeah, yeah maybe I should get the children tested for future things like x-rays, smoking, because they're not good for this type of gene.

HANSEN: For people who are at a very high cancer risk, such as people with Li Fraumeni Syndrome, there is no clear evidence that suggests smoking, x-rays, obesity has a very significant effect on cancer risk, however, it makes sense for people to avoid any meas-

ures such as smoking or excess alcohol consumption which could potentially contribute to their cancer risk in the future.

BAKEWELL: As their mother Rachel feels the decision is hers to make.

RACHEL: They don't know my family and they're not living in my family's shoes. And because we knew there was a lot of this gene within the family I felt that it was always going to be part of our lives now. It's not like my husband's died and end of. There was a strong chance it was going to carry on in the children. So I wanted to know if my children had it too.

BAKEWELL: Let's return now to find out what our panel of experts thinks about how things are developing. Can I have just an initial response to what you feel about this — Richard Ashcroft?

ASHCROFT: We are faced with a slightly artificial distinction between the interests of the children and the welfare and interests of the mother. But I think it's more natural to take the family situation as a whole.

BAKEWELL: Gareth, what's your response?

EVANS: Yes I mean I feel incredibly sympathetic towards Rachel's position here and having someone so uncertain about everything unsettles the family, so there is detriment to the children if the mother is uncomfortable with where they are and not knowing how to move forward. And that has to be balanced against the fact that you're going to have different outcomes in the four children — you're going to have maybe two children without the gene fault, two with — they won't be treated the same. And so it will create a divide between the way the children are managed and treated.

BAKEWELL: But are there certain genetic disorders for which it's easier to concede to the parents if they want testing?

EVANS: I think if there is any proven benefit to the individual child. So for instance in a condition where you develop multiple polyps you can target screening surveillance to pick up the polyps which will turn into cancers starting at around

12 years of age and then you don't have to subject the children who don't have the faulty gene to that sort of an intervention. Now there you have a clear distinction — there is benefit to both the child without the gene fault and to the child with the gene fault. In this situation we have no proven surveillance techniques to offer in childhood.

BAKEWELL: So would you have a judgement that there are certain genetic faults that you would not test for at all?

EVANS: Yes, like for instance Huntingdon's Disease, which is a disease of mid to late adulthood, there is no risk in childhood, there is nothing you can do and even if the parent is interested in finding out whether their children carry the faulty gene we would not under pretty much any circumstances offer testing for that.

BAKEWELL: It's a pretty bleak outlook, isn't it Gareth, if you know you've got a Li Fraumeni gene and it's hard to detect the cancers early, I mean is there any work being done on improving detection?

EVANS: There is a study that started in the UK called Signify where adults who carry faults in the TP53 gene are getting whole body MRI screening. And therefore is able to pick up potentially the malignant tumours that occur in the muscle and the bone and in the soft tissues, it's able to pick up breast cancer, it's able to pick up early brain tumours potentially.

BAKEWELL: Is that likely to become available for children?

EVANS: The problem in childhood is that you're going to need the very young children to do a general anaesthetic for them to stay still enough to go into an MRI machine and we definitely cannot justify that because there are risks with a general anaesthetic.

BAKEWELL: Right, now I want to turn from the medical detail to the psychological background. Deborah, this is a matter of a mother who's suffered bereavement, she's worried about her children, surely the wish to have testing must be psychologically determined?

BOWMAN: Of course she's vulnerable and she's been through a terrible thing but I would be very worried about pathologising her psychologically and suggesting that this is motivated by a grief reaction and wasn't a free choice. We are all shaped by circumstances and one might argue that she has privileged knowledge that most of us don't have.

BAKEWELL: Richard Ashcroft.

ASHCROFT: The mother of the children is lucid and well informed and one has to weigh up what the different possibilities are. The no testing possibility leaves in a situation of considerable uncertainty, we don't know how that will affect her parenting, we don't know how that will affect the children themselves.

BAKEWELL: It is interesting that over 50% of people who are told that they might have the gene don't want to be tested as adults.

ASHCROFT: It's actually reasonably well known across clinical genetic testing, including Huntingdon's, quite a number of people who may be affected don't come forward for testing and quite a number of those who do come forward for testing don't return to collect the results. Now all of that speaks in favour of leaving this testing to the children when they approach maturity.

BAKEWELL: Gareth Evans.

EVANS: The main concern with doing testing in childhood is that if the children test positive and it's likely they will go throughout childhood without any form of cancer, at some stage they will have to adjust to the fact that they're at extremely high risk of cancer — that probably won't happen in childhood it'll happen in their 20s when they're starting to realise oh I'm going to have a family myself. And that could be — and I have experience of that in this particular condition — a really, really difficult adaptation. So there really are so many things going on here.

BAKEWELL: So we're living with genes now, it's really changing our whole outlook on life. I mean, Deborah, there's a whole business of the impact of testing that might have in

the future — I mean lifestyle things like insurance?

BOWMAN: Absolutely and I think it is interesting, isn't it, this pursuit of knowledge and knowledge is neither good nor bad inherently, it's what we do systemically and societally with that. The insurance industry, for example, hasn't always been good and responsive and I think there's something about the ways in which we use information but also share information. So I may be carrying lots of information about myself but I wouldn't necessarily want everyone else to know and I wouldn't necessarily want to disclose on forms. So I think it's not so much about the information but the ways in which we are expected to use that information, share that information and the purposes to which we put it.

BAKEWELL: Gareth Evans.

EVANS: The insurance companies actually are not regulated and they have agreed a moratorium now which has been extended from the original one in 2011 to 2017 where they will not use genetic testing information to calculate insurance premiums for life insurance and critical illness insurance unless it's above a very high level. So at the moment it's not a problem in terms of their test result, however it may change in 2017, there's more and more genetic information coming out, insurance companies may feel they can't hold that moratorium any longer and that would be problematic.

BAKEWELL: It is a bit of a brave new world, Richard?

ASHCROFT: That has such people in it. Possibly. One thing that we sometimes lose sight of is that parents generally do worry about their children and we've given them some new things to worry about. But whether parents have become more anxious as a result of the rise of the availability of different kinds of genetic testing probably not, I think the level of anxiety is more or less constant, you just put it in under different headings.

BAKEWELL: Well let's go on with this particular story. The issue now is should the genetics team allow Rachel to have her children tested? The needs of each child have to be con-

sidered separately. The genetics counsellor.

GENETICS COUNSELLOR: The age ranges of the children between 12 and two was important because the child at the older age could be part of that discussion but the younger child couldn't. A two-year-old can't consent to having a blood test taken, and why they're having it done, whereas with the 12-year-old you could include that person with an age-related conversation about what they knew about the condition and whether they thought they would want to know the result. We're trying to look at the balance between what is right for one child but also right for the family, and that's where I think it's very challenging.

BAKEWELL: This presents Rachel with a series of distressing decisions.

RACHEL: It's hard because some of my kids are too young to make that decision for themselves and to even understand what testing is all about. I felt that the older children would have some understanding.

BAKEWELL: So when is a child old enough to contribute to a decision about testing?

GENETIC COUNSELLOR: A lot depends on what they know of the actual condition, what their experience is and also how the families have talked to them and explained things to them. But you would also look at the family dynamic.

BAKEWELL: Rachel is open with her family.

RACHEL: I did say that I explained everything that was happening with Alan to the children and that they made their own decisions, you know whether they wanted to go to the funeral and things, so I felt that by explaining to them that I would like them to be tested they could then decide for themselves, whether to or not.

BAKEWELL: Given the age range of the children, the team consider whether to test them in sequence, as they each reached the age of twelve say, so each child can be involved in their own decision. But this can present problems.

GENETIC COUNSELLOR: For example if all the older ones haven't got it and the younger one is tested and if you look at nature as 50/50 they'll start thinking well they haven't got it so I have got it, or vice versa. And also you are the last one left not knowing your status and I think sometimes for the younger children they are often older in their years and they can feel excluded from family discussions.

BAKEWELL: Rachel is worried about the consequences of waiting ...

RACHEL: It could be too late. That's how I felt, you know, who knows. Yeah, they could decide for themselves and some of them may not want to know whether they've got the gene or not and I do respect that, but I felt that the only way I could protect my children is by knowing in order for me to be forewarned if anything happens.

GENETIC COUNSELLOR: Having met Rachel I felt that trying to test the children when they all got to say for example ten or twelve was going to be a very drawn out prolonged procedure on top of what had been an extremely traumatic time for the family. But not everybody agreed with that decision.

RACHEL: I'm quite a relaxed person and we live each day as it comes and we try to enjoy it as best we can. I don't believe in prolonging any sort of bad news or anything like that, so I decided I wanted to have them all tested.

GENETIC COUNSELLOR: In Rachel's case, our team were divided as to whether we should test the children at all, and then whether we should test them all at the same time or at which age we should test them. And it was at that point that it was suggested that it was sent to the ethics committee in the hospital to see if they could offer us some guidance.

BAKEWELL: The clinical ethics committee finds this case particularly challenging. A key question is whether testing is in best interests of the children or the mother?

ETHICS COMMITTEE MAN: I found it a very sad case. I did feel however that it wasn't necessarily in the children's best interests to have this done at

this early age, because the family history was so strong that there would always be a very high index of suspicion by the GP, by the doctors, you wouldn't necessarily need to know that the child was definitely positive or not.

BAKEWELL: But others feel differently.

ETHICS COMMITTEE WOMAN: I thought it would seem quite harsh to tell a mother who had been recently bereaved 'and we're not going to allow you to have your children tested for the same condition'. Provided she was sufficiently informed, then we should prioritise her views about what she thought was in the children's best interests. We also felt well at what sort of age would this information be useful, both for the mother but also how would that information be then imparted to the children and their different age ranges.

ETHICS COMMITTEE MAN: Psychologically, it could be quite harmful for the children to be in effect 'labelled' by having this condition and it may get out to their friends. And it could really affect their upbringing in a major way. It might alter the family dynamics quite markedly if some of the children had the condition and others didn't, and it was also taking away their right to make an informed decision once they reach the age of 18 as to whether or not they chose to have this test.

ETHICS COMMITTEE WOMAN: It seemed invidious to sort of separate them up and say 'we know something about one of the children but not all of them'. Whereas often we would start from different perspectives, and through discussion get to some sort of agreement at the end, this caused us real difficulties.

BAKEWELL: At this point we come to our final discussion — what do our experts think. Deborah Bowman, Richard Ashcroft and Gareth Evans. Gareth, you look after families with Li Fraumeni and I wonder what the impact of genetic testing in childhood has on them.

EVANS: Well there have been very few children tested and I have the experience in a family where we were sort of in a sense forced into doing it

because a couple of cousins had been tested and you couldn't have the precedent that one branch of the family could have testing in childhood and the other couldn't. But in that situation I think the testing was beneficial for a long period of time, it stabilised the parental situation where there's huge anxiety and even though the child tested positive there were no detrimental effects on the child. As I said we've got lots of experience of testing children for these sorts of things, not necessarily Li Fraumeni, in childhood and actually children cope very well with being tested at 10-12 and even earlier, it doesn't really impact. There can be mixed messages, don't go to school and say I've got cancer, and that can be a little bit worrying.

BAKEWELL: But presumably it's important to have children tested before they become sexually active because they would be passing it on?

EVANS: Sixteen you can get consent from the adolescent and the parent, certainly at 18 because this has such ramifications.

BAKEWELL: Deborah.

BOWMAN: I actually think it's not about age, I think it's about function and I think that reflects what we know about adolescents making choices about their healthcare, deriving from the Gillett case.

BAKEWELL: The Gillett case gave Mrs Gillett's children the right to birth control didn't it?

BOWMAN: It did, although the principles are generalizable to other aspects of healthcare. And I think the principles are sound, they are about what a young person understands and what's in their interests at a particular time, rather than whether or not they've reached a particular birthday. I think the other interesting thing that plays in here is that young people, where there's illness in the family, will often have a much more sophisticated knowledge of a particular condition than one might expect for their age and Prinscilla Alderson's work with really quite young children has shown us that even if legal consent isn't possible

the principles of assent should be informing what we do.

BAKEWELL: Yes Gareth.

EVANS: Our experience when we do testing often at around 10 to 12 years of age for a number of conditions is that that testing is tied in with this early surveillance, early detection and actually the children find the results of the early surveillance much more telling than the genetic testing. And in this situation we're not going to be offering anything, so it's the test in isolation potentially which still may not have any huge impact on the child and there is a lot of evidence that the bigger impact is on the parents receiving bad news, particularly in the short term and then coming to terms with that bad news.

BAKEWELL: Of course if the mother's allowed to test her children it opens up another whole set of dilemmas, doesn't it, because these children are the age of two to 12 who's going to decide when she tells them?

BOWMAN: I think she will decide when she tells them and again I think if we're prepared to and believe that — and I certainly do — she loves these children, she knows these children better than anyone, she will be well placed to judge when and how to disclose. But of course disclosing to one but not others potentially gives one child knowledge that another doesn't have, so there are all sorts of things to think about. But having heard from Rachel I believe that she will have thought about those things.

BAKEWELL: But children talk to each other and have secrets and threaten each other and can tell friends — the ripples are huge, aren't they?

ASHCROFT: Yes they are and children, like adults, don't always behave well. There's really not much one can do about this. There are all sorts of ways in which - I won't quote Philip Larkin about what parents do to their children - but the way in which living with uncertainty could be difficult for the mother and the children, living where the mother knows something that the children don't know can also be difficult. I don't really see

any way round this. As to when you tell each individual children that depends very much on the child themselves as they're growing up and their ability to cope.

BAKEWELL: Would you think — agree with that, Gareth?

EVANS: It's extremely difficult and I wouldn't say it's their 12th birthday or anything like that. The one thing I would say is that if the children ask the question they're ready for the answer. So I would be sensitive to the children asking the sorts of question which say I really want to know and if they do then that's the time they should be told.

BAKEWELL: So how much does the character of the parents influence whether you choose to test or not — what would you say, Richard?

ASHCROFT: It's a very difficult question isn't it because we don't normally like to take a view as to the character of the patient, make a moral judgement about what sort of person this is, though obviously that influences how you approach a consultation, how you speak to them, what kind of support you offer and so forth and so on. So we conveniently box it up and call it patient autonomy and say 'oh, it's up to you'. But that doesn't answer any questions.

BAKEWELL: But Deborah you've got teenage children ...

BOWMAN: I have got teenage children.

BAKEWELL: What would — what can you make of this dilemma for a parent?

BOWMAN: Oh gosh, I mean I wouldn't want to generalise for my own children but I think when you exist in a family it's relational, isn't it, and so this idea of autonomy for each individual that doesn't bump up against or isn't informed by your relationships with those around you is a nonsense. And there are lots of things that I've decided for my children with their very best interests at heart with which they may not agree necessarily but I think there is a necessary understanding within a family that love and respect will generally mean you try to do your best and it may not be what

other families do but it's well motivated and I think in genetics, maybe more than any other area I can think of at the moment, this idea of individual autonomy and treating one person is really problematic if you want to get to the heart of the moral questions that we're being asked to address.

BAKEWELL: And Gareth you appreciate that too I'm sure?

EVANS: Absolutely, I mean in this situation we're faced with a mother who has only a one in 16 chance that she's going to get the good news that all four of her children are clear. So however it's done unfortunately there is going to be a very high chance that there's bad news along the way.

BAKEWELL: Now you have to play the ethics committee and I want to know what each of you would advise in this situation. Deborah.

BOWMAN: I'm quite surprised because I think normally I'm very much for children being involved in making their own choices but I feel immensely sympathetic to Rachel in this case and I do feel that the children should be tested altogether.

BAKEWELL: Richard.

ASHCROFT: I ask myself two questions, one question is what Rachel should be allowed to do and the other is what I would do if I were Rachel. And my rather uncertain and tentative conclusion is that Rachel should be allowed to do what she is asking for and I have no idea what I would do if I were her.

BAKEWELL: Gareth.

EVANS: That's an interesting one. I personally wouldn't want my children tested but I don't think that that should take away from this situation where clearly you have a very distressed mother and I think the decision has to be a further discussion and if mother is absolutely adamant that may certainly in the short to medium term be in the better interests of the children. And I wouldn't draw it out, drawing this out for this poor mother over four separate episodes and waiting another eight years for her youngest child to be tested could be deeply traumatic. So it's all or none together.

BAKEWELL: Right, let's find out what happened in this real life medical case. The chair of the clinical ethics committee.

ETHICS COMMITTEE MAN: We resolved the division by going down both routes to a certain extent in that we recommended firstly that the mother had the full implications of the decision to test the children explained to her. We wanted the mother also to consider whether it might be more appropriate to test them as they were older and could help with that decision-making. But ultimately the majority of the group felt that if she really wanted the testing, having undergone all of that, that she should be allowed to proceed with that. I felt that the mother would go ahead and want to have all her children tested but I also felt that that probably wasn't the right thing to do.

RACHEL: It was left down to me as a parent to either get them tested or whether I wanted to leave it. I spoke it over with the family and we all said that we would like to find out. So I decided to go and test.

BAKEWELL: The genetics councellor.

GENETICS COUNSELLOR: I talked to Rachel about how she would prepare the children. The older ones would need to be aware why they were coming and that we would talk to them about why we were taking a blood sample in a language they could understand, in that we now knew that their daddy had a condition that could affect them and that if we knew that they were at risk then they would know when they needed to tell her if they weren't feeling well so their doctors could keep a close eye on them.

RACHEL: I told the children what they were going to be tested for. The older ones they decided whether they wanted to go ahead and they could change their mind at any time. They were obviously more understanding, I mean I didn't go into too much detail because I didn't want to bombard them with all this science. The younger ones, they didn't have a say in it really, but yeah — they all went ahead and had it done.

GENETICS COUNSELLOR: Rachel brought the children in one

by one and we went through
the consent form for each one.
Checked the name, date of
birth, all those details and
talked to the children for whom
it was relevant and then took
their blood sample.

BAKEWELL: Two weeks later
Rachel attended the clinic with
her father to get the test
results for each of her four
children.

RACHEL: There was always going
to be a chance that half the
children would have the gene.
And some have tested posi-
tive. I was devastated because
more than half are affected.
So unfortunately for me this
gene is going to be in my life
forever, and its complications.
I thought maybe if I didn't
have kids but that's the past
and I certainly wouldn't be
without the children. We just
take each day as it comes and
I don't wrap them up in cotton
wool, you know, I'm not going
to start saying 'oh, be extra
careful'. It will be on their
medical notes to make the doc-
tor more aware.

BAKEWELL: The children who have
tested positive have a check-up
each year with a paediatrician.
Rachel recently told her eldest
child which of them have the
condition. She will tell the
others when they are old enough
to understand and when the time
feels right.

RACHEL: Well the way I look at
it is there's no point worrying
about it unless it happens. I
feel that I have got possibly
a good 10 years before any of
this is mentioned again. Obvi-
ously it's going to be at the
back of my mind, but yeah, I'm
not going to start approaching
the subject again until then.

ENDS

BAKEWELL: Organ transplants are one of the success stories of modern medicine. And over the years, views on who can receive organs and who can donate have changed. So what happens when parents of a dying child want to donate that child's organs after death? What about infants and newborn babies? Who decides? Who has the right to decide?

Welcome to Inside the Ethics Committee.

It's early 2012. Kenny and Elizabeth had been trying for a baby and to their delight a pregnancy test brings the news they have been hoping for.

ELIZABETH: I was delighted to be pregnant because I didn't know if it would happen or not but then just the nervousness of waiting on your scan, just to know that things are or aren't okay, so yeah, mixed feelings.

BAKEWELL: The scan date arrives.

ELIZABETH: We went for a 12 week scan and obviously excited and nervous to be seeing the baby and then realised there were two babies and we were expecting twins but then it became apparent, quite quickly, that there was a problem.

OBSTETRICIAN: One twin looked normal and the other twin had the appearances of a major abnormality called anencephaly.

BAKEWELL: The obstetrician explains the condition.

OBSTETRICIAN: Anencephaly literally means no brain. When it's in the womb we realise that it's not that, the baby does have a brain, it's just not protected by the skull and the skin over the brain. And as a result during the pregnancy the brain effectively fails to develop, resulting in the appearance by the time the baby's born of there not really being much brain.

BAKEWELL: The prognosis for babies with this condition is bleak.

OBSTETRICIAN: There is an increased chance of stillbirth, we know that, but I can't put a figure on it. It may survive the labour. Of those babies that survive the labour then you're probably looking at most babies only living moments — minutes, maybe half an hour or so. There are exceptional cases reported of babies living days or weeks but it's likely you've only got minutes.

ELIZABETH: I don't think it really sunk in to begin with actually. We'd been blessed with two little babies here and just trying to take in that information that one is not going to survive much beyond the birth.

BAKEWELL: The obstetrician explains the options to Kenny and Elizabeth. Termination of the foetus with anencephaly is one of them. But they're having twins and there are risks associated.

OBSTETRICIAN: There is a chance that its death will result in the loss of the healthy one and that figure probably goes up the later you do it. So there's around a 10% chance of losing an entirely healthy baby for the sake of not having to deliver a baby with abnormalities.

ELIZABETH: I never thought I'd have to face the situation where I was considering terminating my own baby or not. I really wanted to be a mother for many years so it's quite frightening obviously having to think through what do I really believe here, what's the right thing to do.

KENNY: Ultimately we wanted whatever was going to give us the best chance of having a baby survive at all.

BAKEWELL
The alternative is for Kenny and Elizabeth to avoid that 10% risk associated with termination and continue with the pregnancy of both twins. But if they do, there is a risk that the baby with anencephaly could die in the womb.

OBSTETRICIAN: In a pregnancy with twins if one baby dies than there's a risk that that will cause premature labour. So you could argue that maybe it's better to face that 10% and get it all over with rather than run the risk of the one with the abnormality causing labour at 24 weeks and causing abnor-malities in the survivor just through prematurity. But it's a reasonable estimate that the chances of that were on balance a good bit lower than 10%.

BAKEWELL: But if the couple decide to continue the pregnancy of both twins, Elizabeth is all too aware of the impact this could have on her.

ELIZABETH: I would then need to carry a baby that I knew was ultimately not going to survive. So they were very good at trying to help me understand how that could perhaps affect me further down the line, as well as the practical implications of maybe a premature birth.

BAKEWELL: But there are also benefits for continuing.

OBSTETRICIAN: For about the 15-20% of women who let nature take its course there's clearly real value and one of those values is having public recognition that they've had a baby, including the fact that they get a birth certificate and a death certificate and all the kind of societal ceremony that goes with life and death adds value to the grieving.

BAKEWELL: But giving couples this option is relatively new. The obstetrician remembers being shocked 15 years ago when a woman decided to go through with such a pregnancy, it was her decision that changed his outlook.

OBSTETRICIAN: And I think since then we've increasingly said well do what you like. But it took a while to get a mind shift and I think that's likely to be variable up and down the country, just still somewhat dependent on who you happen to meet.

BAKEWELL: The decision is Elizabeth and Kenny's to make and there's one other crucial perspective.

KENNY: Our understanding would be that life begins at conception and that both of these babies had that potential for life that was God-given and were to be treasured. So that would be the basis on which you're trying to inform our decision making.

BAKEWELL: Let's pause here and meet two of my panel to discuss today's case. Susan Bewley is Professor of Complex Obstetrics at Kings College London. And John Wyatt, is Emeritus Professor of Neonatology at University College London.

Susan Bewley, can I ask you to enlarge, first, on the relative risks involved of either continuing the pregnancy or terminating the foetus with anencephaly?

BEWLEY: It's very complex because there's two issues, one the baby with the problem that is inevitably fatal and secondly, the twin pregnancy. Any pregnancy with twins has more complications and you can either carry on with greater chances of anaemia, caesareans, preeclampsia etc., and prematurity for both the twin that's going to live and the twin that's going to die. You can end the whole pregnancy, obviously that's unacceptable, or we can do a procedure that terminates one of the pregnancies. That has a risk of miscarriage, sometimes of breaking the water, sometimes of bleeding, sometimes of going into labour a bit later but after a few weeks if that risk of losing the whole pregnancy doesn't happen it's like converting a twin pregnancy to a single pregnancy.

BAKEWELL: And what about the risks to the mother?

BEWLEY: Well the risks to the mother are not so much from a termination but they would be the risks of a twin pregnancy. So there's more risks of every complication of pregnancy — going into labour prematurely, having blood pressure diseases, having bleeding, having a caesarean, having a haemorrhage afterwards. So normally a singleton pregnancy has much less risks than any twin pregnancy.

BAKEWELL: Right now we've heard that it's increasingly the case that women with such pregnancies go full term, why has that happened — John?

WYATT: Yes it's certainly my experience too that when the options are put towards parents in this kind of way, following the tragic discovery of a very severe, maybe lethal abnormality, increasingly some parents feel that allowing the pregnancy to proceed and wishing to

meet their baby after birth is something that they would wish to carry on. And certainly my experience has been over the years that I've had the privilege of caring for a significant number of babies in this kind of situation and I've seen the positive aspects of having an opportunity to meet your baby. And clearly if a termination is performed during pregnancy this is a very private event which is often not talked about, apart from with very few close confidantes and so on, in converse the birth of a baby even a baby who may only live a matter of minutes or hours or days is a much more public event, there is a social recognition of the event and therefore is a support mechanism for parents.

BAKEWELL: It's not surprising that now we have scanning of course the bonding seems to happen much earlier and the child in the womb has a reality that it never had years ago — do you think that's so?

BEWLEY: I certainly think that's so, mothers have always felt their babies moving, so they've always had a bond and a relationship but I think we prioritise the visual, so seeing a baby on a scan does make it more real and it makes it more real to other parties — the father, the friends and so forth. So we have changed our relationship with the foetus in the womb.

WYATT: One of the things I notice is that the baby's photo album which used to start on the moment of birth now invariably starts with a fuzzy grainy image — this is you when you were only a few weeks gestation.

BAKEWELL: What is interesting though in this terrible case is faced with the decision to go through with the pregnancy or not is how traumatic it might be, is that a word that is applicable at all?

BEWLEY: Oh absolutely and I think there's something particularly difficult about a twin pregnancy and we see that both in the womb and I'm sure John sees it afterwards when you have one twin who's alive and thriving and another who's ill or dying. It's not possible in the brain to be looking forward positively like most pregnant women at the same

time as thinking and preparing for death, I think that is very hard indeed.

WYATT: Yes and that's certainly my experience. Paradoxically it seems that where twins — one of whom survives and does well and one of whom dies — it puts parents in an extraordinarily emotional double bind, that they can't really enjoy the baby they have because they're constantly reminded of the one that died and they can't really grieve for the one that died because they're having to face all the planning and decisions of the one that's alive. And sometimes I'm afraid family and friends are often very insensitive and would say things like well at least you've got one, just be grateful and would not understand the kind of emotional conflict that parents find themselves in.

BAKEWELL: Insensitive people, like me, might say things like — wouldn't it be better to get the trauma over and have it resolved rather than proceed through nine months of distress — what do you say to me?

BEWLEY: I think we can't put ourselves into other people's shoes in that way, it's too difficult.

WYATT: There's a medical feeling that a termination is like a quick fix, it just solves the problem. Of course in the real world it's not as simple as that and these are profoundly complex issues which touches at a very deep part of our nature. So the idea that a termination just solves the problem, in my experience, it's very unlikely that that will be the case. Therefore what I often say when talking to parents as of course you have to live with this for the rest of your life, you have to live with the knowledge that the decision you made was for the best and in the end no one can tell you what you must do.

BAKEWELL: And if Elizabeth and Kenny do decide to continue with the pregnancy the birth of the healthy twin takes precedent — is that right, Susan?

BEWLEY: Well I think the health of the mother takes precedence, we'd have to make a decision about whether we do a caesarean for the usual reasons — that's some threat to the mother or a threat to the healthy baby. So

we do have to think ahead and we have to realise that this is quite likely — 50% of babies in twin pregnancies are born prematurely — so it's likely that this is something that will happen and occur to us out of hours, so we must plan and discuss all the possibilities in front of us.

BAKEWELL: Right. Well now let's get back to the story. Elizabeth and Kenny make their decision. They decide to see the pregnancy through with both twins.

ELIZABETH: We also decided to find out the sex of the babies so we could then refer to them as our little boy and our little girl and that was really special. I guess that was our time with him plus you could feel him moving inside. So you connect more and more with these two little babies even though you know that one of them is only going to be with you for a very short time.

BAKEWELL: The neonatologist, who will be looking after the baby with anencephaly, talks to the couple about how they might like to spend any precious time they have with him, if he's born alive.

NEONATOLOGIST: A baby who has been born without a brain has the possibility of surviving for a few minutes, could be a few hours, or it could even be days. It's a case of exploring what options might be available to the parents for them to spend time with their baby, does it have to be in the hospital, could it be home, could it be a hospice? Things that perhaps you wouldn't necessarily think about when you're just faced with such bad news.

ELIZABETH: Meanwhile I'm getting more and more pregnant and you can feel this little baby is alive and kicking literally. So whilst he was inside me he was alive but then knowing that ultimately the birth would be the beginning of the end.

KENNY: You had trips to Mothercare but you also had trips to the cemetery.

ELIZABETH: It's just quite surreal almost. You want to be excited about the babies and of course you go into Mothercare and they don't know the story and you've just been up the cemetery looking at plots to work out if that's where you'd like to bury your son. And at times I guess felt I wasn't excited enough about the other baby because you're mourning already the loss of the baby that you know is not going to survive.

BAKEWELL: Elizabeth is also apprehensive about meeting their little boy.

ELIZABETH: I was really scared that I was going to be scared to look at my own little baby, which is quite a horrible thought, so it was helpful just to know in advance what he might look like, what the slight differences might be compared to other baby who was hopefully healthy.

BAKEWELL: She meets regularly with her midwife who tries to prepare her.

MIDWIFE: Facially, eyes, nose, mouth are all there and the chin and then protruding eyes and then basically we'd come up to about mid-forehead and then the skull, top to back, has not formed. To show Elizabeth photographs gave her the idea of what this baby's going to look like. The options were given — do you want your baby to be given to you straightaway, do you want the head to be covered, wrapping the baby up or putting a hat on, what would you want us to do?

BAKEWELL: Early on in the discussions, the obstetrician raises another issue for the couple to consider — organ donation.

KENNY: You can see the obvious benefits in that you've got a pretty hopeless situation where this baby's going to die and everyone kind of knows that there are shortages with regard to organs for all sorts of problems. And everything else is going to be there, apart from the abnormality with the skull and the brain. It sounds like a good idea.

ELIZABETH: We knew that our little boy wasn't going to survive but equally we want to be able to help other families, so that they're not facing what we're facing — the loss of their own child.

KENNY: There was a potential here for several other families somewhere else and he was going to be very generous, literally giving of himself to others.

BAKEWELL: Given Elizabeth and Kenny's interest, the obstetrician starts to explore the possibility further.

OBSTETRICIAN: I e-mailed a group of colleagues — specialists in foetal medicine — throughout the whole UK and got a pretty unanimous — this isn't possible. And this was a real learning experience for me, not an area I've dealt with at all. Independently of course we also contacted the local transplant coordinator and rapidly realised this was a very contentious area and needed to be escalated up.

BAKEWELL: One of the transplant coordinators.

TRANSPLANT COORDINATOR: This request was very unusual because babies so young there's very few that will actually go on to donation and in particular anencephaly, this was something which had never been done in the UK before.

BAKEWELL: The organ donation service contacts the UK Donation Ethics Committee.

So under what circumstances can the organs of babies and children be donated? The paediatrician on the committee.

PAEDIATRICIAN: These are children and infants in whom it's quite clear that carrying on aggressive invasive intensive care is no longer in their best interests. With the family's agreement intensive care would usually be withdrawn. And so once the heart has stopped for five minutes, the lungs aren't working and they're verified as dead, then organ retrieval can occur.

BAKEWELL: This includes newborn babies. It's rare but it does happen. But this baby has anencephaly - he lacks a brain. Does this change things?

TRANSPLANT COORDINATOR: This is definitely different to a newborn without the diagnosis of anencephaly. This was something that we really wanted to consider, was this actually a potential, can a baby with anencephaly actually donate?

BAKEWELL: Right, well let's go back to the panel. Joining us

now is Bobbie Farsides, who's the Professor of Clinical Ethics at Brighton and Sussex Medical School.

Let me ask you Bobbie, first, you sit on the UK Donation Ethics Committee, don't you?

FARSIDES: I do, yes.

BAKEWELL: And we've just heard that newborn babies' organs can be retrieved after death but only under specific circumstances, can you explain that?

FARSIDES: Yes. As we've already heard it's actually rare for very young children or babies to donate in this country. And if they are able to donate it is because their death has been defined as death after circulatory death which means that their heart has stopped working, their circulation has stopped working. And really it's the commonsensical definition of death that we've worked with for hundreds of years.

BAKEWELL: Now the interesting thing is that we also hear in public discourse about donation happening after brain stem death, so why doesn't that apply? John.

WYATT: As you say it is well recognised that in cases where there is evidence of irreversible damage to the brain, particularly the brain stem, that in older children and adults it has become standard practice for donation to be considered because death can be diagnosed by these neurological criteria. When the criteria were debated and discussed more than 20 years ago babies under two months of age were excluded because of concerns about how reliable those criteria are in very small babies.

BAKEWELL: Bobbie.

FARSIDES: The issue is that we don't feel at present that we have the criteria to judge brain stem death in such tiny babies. In recent years we've become much more comfortable with donation after circulatory death in adults and older children and this has opened up the possibility of thinking of donation for very young children or babies because here we would feel confident in knowing that the child had died and that we were safe to proceed with a donation.

BAKEWELL: Now this child in question here has no brain, does that make a difference to all these options?

FARSIDES: This child is the very much wanted child and I think we just have to think about their interests in protecting the dignity of their child, the interests of their child and in one sense the brain or the absence of it is irrelevant.

BAKEWELL: John, what do you think about this baby born without a brain?

WYATT: Yes I would very much agree with that, although there are some people who have argued that a baby that doesn't have a brain can't be regarded as a person in some way, that it comes in a different category from a human person. I personally wouldn't agree with that and I think my experience — and I think it's shown out very clearly in these parents — is that as professionals we should respect their desire to see this child as a unique individual and a member of their family.

BAKEWELL: Does a child like this have anything you could call consciousness?

WYATT: Again this is a matter of scientific controversy. Most neuroscientists would say that since consciousness comes from the cortex, the lining surface of the brain, and since that isn't present here then there can't be any kind of consciousness. Having said that I've had the experience of caring for babies with this condition. The babies sometimes do show some signs of responsiveness — they seem to move and stroke their face — so I would be cautious to be absolutely dogmatic and say there's no kind of awareness or consciousness.

BAKEWELL: Do they have rights, do they have the rights of a newborn baby? Bobbie.

FARSIDES: We have obligations to this child, I think is probably a better way of thinking about it, because as John said some people want to base claims to rights in a particular type of identity in personhood and we would get into a sort of controversial argument about whether this child is a person and therefore has interests upon which we can base rights.

But I think we would say this child is a member of a family to whom we have responsibilities and we would want to think of how best to balance the various obligations and duties that we have to do the best for this family as a whole.

BAKEWELL: But who is going to decide whether this baby's organs can be used for transplant?

WYATT: Once the baby is born as a neonatologist we have a duty of care to the baby and in this case to both babies. And our duty of care is to act in the baby's best interests. And this is where the challenge comes, of course we also have a duty of care to parents and to respect their wishes and so on. So the decisions about the cares of babies after delivery should be a collaboration between the medical team and the parents. And that together there should be an attempt to reach agreement.

BAKEWELL: Bobbie.

FARSIDES: It is a collaborative decision and it's a decision I would suggest that cannot be anticipated in advance. And I think in talking about the options that are available, particularly organ donation, one has to prepare the family for the possibility that it might not be able to happen but also for the real possibility that they might change their mind when they have their baby in front of them. So I think it's keeping the conversation going whilst making practical arrangements that allow for the choice that the family will hopefully feel able to make.

BAKEWELL: Well let's get back to the story. The UK Donation Ethics Committee consider whether it's ethical for the organs of a newborn baby with anencephaly to be donated after death.

PAEDIATRICIAN: My previous responses and those of everyone else I know who've been involved in this field are that it can't be done. But in terms of the newer thoughts about donation after their heart has stopped beating, they're not breathing — it really gets one thinking that maybe this is something that could happen.

BAKEWELL: After all, apart from the absence of its brain, this

baby is like any other. So what organs can be retrieved from a newborn?

PAEDIATRICIAN: The most likely organs that could be donated are the kidneys, which might well be able to be given to an adult. Liver cells can be transplanted. The other possibility is small bowel transplants from very small babies to other babies, the same with lungs. Heart transplants happen but that's a difficult one.

BAKEWELL: And there are practical considerations. This baby's organs will only be viable for donation if he is born alive. After the birth, and once the baby has been declared dead, then the organs can be retrieved.

But a transplant is only possible if there's time for recipients to be identified and their surgical teams mobilised. So all teams need to be ready.

The problem here is that no one can predict when Elizabeth will give birth. The obstetrician must prioritise the needs of her healthy twin, so planning a caesarean around donation would be inappropriate.

So the team considers whether prolonging life after birth, by supporting the baby's breathing, would be acceptable to enable transplantation to take place.

OBSTETRICIAN: We were proposing the idea of ventilating a baby who we knew was going to die and we had to be sure that people felt that was an appropriate use of resource, we had to be sure that people were comfortable that it wasn't causing any suffering for the baby.

BAKEWELL: Kenny and Elizabeth gave a lot of thought to this question.

KENNY: We knew our little boy was going to have a very short life and we wanted it to be as special as possible and pain free and we don't want him suffering and by intervening are you doing that, and if you are are the benefits of the transplant going to outweigh the cost that he is going to have to take — and he doesn't have a choice, we're making the choice for him.

OBSTETRICIAN: We also needed everyone involved to be on board, you know this is a very contentious area and we have a great team, so we needed to be sure we weren't upsetting anyone.

BAKEWELL: The neonatologist, who will be looking after this baby at birth.

NEONATOLOGIST: To be honest we weren't really sure how a lot of people would take it and we felt that perhaps the best way was initially to talk to the senior members of the team. These would be people who'd had a lot more experience. What we didn't want was a situation where there was the sort of background of I don't want this to happen.

BAKEWELL: He approaches one of the senior nurses.

NEONATAL NURSE: I was a bit taken aback because I'd never come across this before. So I had to go away and reflect on that. And I thought actually this is something that's going to help them through this very difficult time and the possibility that another family would benefit from the very generous act.

BAKEWELL: The midwife knows that ventilating this baby could jeopardise the precious time the couple have with him for its very short life.

MIDWIFE: I've witnessed babies who have just died in their parents' arms and it's a very peaceful thing to happen. It's hard to say how I feel because I would say I'm a bit mixed about it.

NEONATOLOGIST: My worries were that we would end in a situation where mum was in one part of the hospital with the healthy twin and the anencephalic baby being ventilated in another part of the hospital and we wouldn't have the opportunity to reunite them before organ donation went ahead.

BAKEWELL: The obstetrician feels less conflicted.

OBSTETRICIAN: I was personally comfortable with the idea of ventilating simply for the point of organ donation. Primarily for the comfort it would provide for the parents, this is the most significant brain abnormality you can have and I didn't see there was a harm in ventilating so that the transplant team could be mobilised.

BAKEWELL: The UK Donation Ethics Committee consider this issue.

PAEDIATRICIAN: To put someone on a ventilator purely for the purpose of organ donation that's really a step, as far as I'm aware, nobody's taken in paediatrics. My personal views, I have to say, vary over time with that. But the best interests of that baby, which is our standard in terms of child health, are they met by looking at the baby as part of the family and thinking about the gift of donation or are we somehow using that baby as a means to procure organs? I don't think that's true but I think lots of other people would have different views about that, so I don't think is a straightforward issue at all.

BAKEWELL: While mulling the issue of ventilation over the picture becomes more complex still.

ELIZABETH: The other impact of ventilating him meant that we knew we would have some time with him but also give our families the opportunity, our parents, the chance to meet him and hold him.

KENNY: I think anything that we could do to make that more likely then we were going to consider.

BAKEWELL: So, to what lengths can a team go to keep a dying child alive?

PAEDIATRICIAN: There are some limits on what we feel it's reasonable to do, so we wouldn't usually start a new powerful drug to enable them to stay alive a bit longer for someone else to come. Whereas to carry one on that's already happening is kind of acceptable.

BAKEWELL: Here the team would be starting ventilation, rather than just continuing it. But the couple have other reasons to prolong their son's life.

ELIZABETH: We also wanted to get him baptised, that was really important to us, just to acknowledge his life and just how special he was and how special he was in God's eyes.

KENNY: He was going to go to heaven regardless of whether

he was baptised or not but it involved God in the short life that he had and I suppose we believe that is for his good, as well as for our good.

ELIZABETH: Obviously he didn't have the ability to make those decisions so you want to make the best decisions for him and for his sister. So as well as obviously wanting to try and proceed with the transplant, if that worked out, as long as it wasn't for a prolonged period of time I didn't feel that it was the wrong thing to do.

BAKEWELL: The UK Donation Ethics Committee considers whether these wider benefits, in addition to enabling organ donation, might tip the balance in favour of ventilation.

PAEDIATRICIAN: It's fair to say within the room there's a difference of opinion from people who thought the family centred best interest approach would enable elective ventilation in this circumstance with this family. To others who thought this was morally something that should not be undertaken, not just in encephalic infants but in any human being, particularly in children who would have no way to say they consented, weren't able to decide in any way shape of form what's done to them.

BAKEWELL: Right, let's come back to the panel here. We have a baby who is dying but the team and the parents are thinking of ventilating him to keep him alive. Now what concerns do you have about that? Susan.

BEWLEY: I think I'd start with the — just because we can doesn't mean we ought. And talking about death while you've got a baby that's moving in your womb is extremely difficult and I think we have to talk about good deaths and bad deaths and all the practicalities that will be involved — putting needles in the baby, putting tubes down, separating the baby.

BAKEWELL: Just on the medical matter would this baby feel pain? John.

WYATT: Of course we can't know for certain whether the baby would feel pain but I think — and I think most neonatologists would agree that we should presume that the baby can

feel pain and therefore if we thought there was any possibility that the baby was suffering and particularly if we were going to do invasive treatments like mechanical ventilation that we would give powerful painkillers in order to prevent any possibility that the baby was in distress. But it does raise the wider question of is it right to be doing this at all and the problem with modern neonatal intensive care is that we've got very powerful technology, it is possible to keep babies alive under extraordinary circumstances but we need great wisdom to know whether this is the right thing to do. My experience is that the best way for a baby to die is in the parents' arm, in privacy with support from staff as necessary. Conversely death in an intensive care unit is a rather different thing. So it is a very painful dilemma. On the other hand I do recognise that the parents long to see some good come out of this terrible tragedy and their desire to see a positive outcome through transplantation is also something that I would recognise and honour.

BAKEWELL: Bobbie, what do you think?

FARSIDES: We mustn't underestimate that any donor family makes sacrifices. If your loved one is an adult that dies there might be ways in which they die differently to facilitate donation. But we're often reassured in that situation because we know the wishes of that adult and they might have made it very clear this is something that they wanted to do. Here we're talking about the parents' wishes for the baby and for the family and I value the idea of legacy, the idea that this child will have done something — as his father said — incredibly generous but I think we do have to be very cautious in our balancing.

BAKEWELL: Now Kenny and Elizabeth are Christians and Kenny had mentioned the identity of the child in the eyes of God and the importance of baptism, now John what do you feel about that?

WYATT: Well many parents would see that recognising the significance of their baby before birth and shortly after birth with some kind of ceremony, such as baptism or other reli-

gious ceremonies in other faith groups, is a very important and significant part of that. Having said that all major faith groups recognise that it's possible for these kind of ceremonies to be performed very rapidly, shortly after birth and so on, and therefore although it may be preferable to delay the process to allow a more formal ceremony to take place I would question whether that's really justified.

BAKEWELL: And what about you Bobbie?

FARSIDES: I think we have to bear in mind that we are always, when we talk about donation after death, dealing with tragedy at the same time as the opportunity to be altruistic, the opportunity to do something quite amazing. And different families will see that offer in different ways. Clearly this is something this family wanted to seriously consider and I think it's to the credit of the medical team that they looked into the possibility but they also looked into how well they, as a team, would cope with facilitating that choice if it were to go ahead. But we also have decisions to make at probably a higher level about how far we wish to go in order to say that somebody who can't express their own wishes about donation should be able to give a good donation.

BAKEWELL: Well this is the moment when I put you on the spot and pretend that you are this actual ethics committee, you've heard the story presented by Kenny and Elizabeth's case, what would you advise — would you advise ventilation for the purpose of donation alone, for the other benefits as well — the benefits of bonding and the religious ceremonies we've referred to — or not at all. What would your advice be? Susan.

BEWLEY: I'm a doctor, I want to fight nature and all the cruel things it brings but from time to time I think the image of letting nature takes it course can be very helpful and at the same time as recognising the altruism and the care and the love these parents had for both their babies I think we have to sometimes say we don't have to use our powerful tools and we want to have a dignified death and I would be rather reluctant to go along the invasive path.

BAKEWELL: John.

WYATT: Well I recognise this is an agonisingly difficult problem and I recognise the very noble desires of the parents and their generosity, their desire that the organs could be used for other desperately sick children but I am very uneasy about using invasive medical treatment for these purposes, even with the additional benefits of enabling other ceremonies, enabling more of the family to be there.

BAKEWELL: Bobbie.

FARSIDES: My advice would be to think of this as a package, to not separate donation and the other considerations but to say our priority here to offer the best possible end of life care to this infant and their family. When this case came to us in the UK Donation Ethics Committee we were struck by the fact that this had to ultimately be a decision that rested with the parents and the medical team in terms of what they were prepared to do on behalf of this family. But we did, at the same time, advise that ventilation would be in our mind an extreme intervention and one that would have to be thought about extremely carefully.

BAKEWELL: Thank you all very much - John Wyatt, Susan Bewley and Bobbie Farsides.

So now let's hear what the UK Donation Ethics Committee advised and what happened in this case.

PAEDIATRICIAN: The feeling was that putting a baby on to life support machines to keep it alive for the purposes of organ donation alone was not ethically acceptable. In fact similarly for the purposes of having other things happen, such as relatives visit or Christening, again on its own ventilating a baby for those things was something that was quite troubling but was slightly more of a debate. In fact it was only when the combination of the two things — so putting a baby on life support for the purposes of spending more time with the family, Christening, and then organ donation on top of that, it was felt that that was ethically something that could be permitted.

OBSTETRICIAN: Eventually after all the discussions it was agreed that if they wanted it at the time and if that baby had vigorous enough signs of life to justify it then some attempt at ventilation would be considered.

BAKEWELL: In the intervening weeks Elizabeth and Kenny met with their transplant team to discuss the plans. At 34 weeks, Elizabeth's waters broke and the babies needed to be delivered. The first baby, the healthy one was breach — a reason to do a caesarean.

ELIZABETH: Our little girl was first, we were very fortunate that she was well and didn't need any extra help, even though she was six weeks early. I guess I was worried that our little boy would come out stillborn and wouldn't be breathing at all but he came out breathing, which was lovely and I got a glimpse of him before he was checked over.

BAKEWELL: The neonatal nurse in charge of the baby.

NEONATAL NURSE: I attended to the baby's head, put a hat on him, put something in the hat to make the head more round, the baby was examined by the consultant and then after that we attached the baby to some monitoring equipment and Elizabeth was able to hold both twins.

NEONATOLOGIST: The transplant coordinators were working feverishly behind the scenes, phoning various places around the UK and I think Europe as well, to see were these organs wanted by anybody.

ELIZABETH: We got a few photographs taken in theatre in case that was the only time they would be together and that he would be alive.

KENNY: And we had that little time in theatre where there were no tubes or anything.

NEONATAL NURSE: After a few minutes the baby's oxygen levels started to drop quite dramatically so I asked the consultant to come back in and Elizabeth said is it time, because she knew. We took the baby through to the neonatal unit where the baby was given some sedation, which is normal if babies are going to have a tube inserted into the tra-

chea, and then the consultant in charge intubated the baby and we attached the baby to the ventilator.

BAKEWELL: Elizabeth was moved from theatre to a private room in the intensive care unit where their son was on the ventilator, so that she and Kenny could spend time with both babies.

ELIZABETH: It meant we had both babies together, we took lots of photographs, the grandparents all managed to come and spend time with their two new grandchildren. They met one of their aunties.

NEONATAL NURSE: In the meantime we found out there was as yet no recipient, I kept asking the consultant but there was — no there's no news, there's no news, we're still waiting to hear.

KENNY: We were able to get him baptised knowing that he wasn't going to stop breathing because the machine was going to breathe for him.

ELIZABETH: That was just a really special time, especially for later on when it was just the four of us after our families had gone home, later in the evening, it was just lovely to be just the four of us in that little room together.

BAKEWELL: Eventually the transplant coordinator received news about the transplant. Due to the baby's low birth weight and size, there were no suitable recipients that day.

TRANSPLANT COORDINATOR: We had to then go and speak to the parents and let them know but sadly on this day I was not able to go forward with any of the organs for transplant.

ELIZABETH: Beforehand I thought I would be more disappointed than I actually was. I still felt that we'd done the right thing.

NEONATOLOGIST: It then meant that we switched care from one of intensive care to one of palliative care.

BAKEWELL: When Elizabeth and Kenny felt ready to say goodbye, their son was taken off the ventilator.

KENNY: He continued to breathe for a number of hours and sur-

vived well into the following
morning.

OBSTETRICIAN: The prolonging
of life didn't end up resulting
in a transplant but we'd done
everything we possibly could
and of course good arguably has
come out of it.

BAKEWELL: The ethical discus-
sions that this case triggered
two years ago, have helped pave
the way for another family.
Within the last year, organs
from their baby with anenceph-
aly were donated for the bene-
fit of others - the first such
donation in the UK: the baby
was not ventilated to keep him
alive.

And the experience for Kenny
and Elizabeth lives on.

ELIZABETH: In the end we had
twelve hours with him, part of
that on the ventilator, and
part of that breathing himself.
It helps afterwards when you're
mourning his loss just to look
back at the photographs and to
smile of those lovely few hours
that we spent together.

ENDS

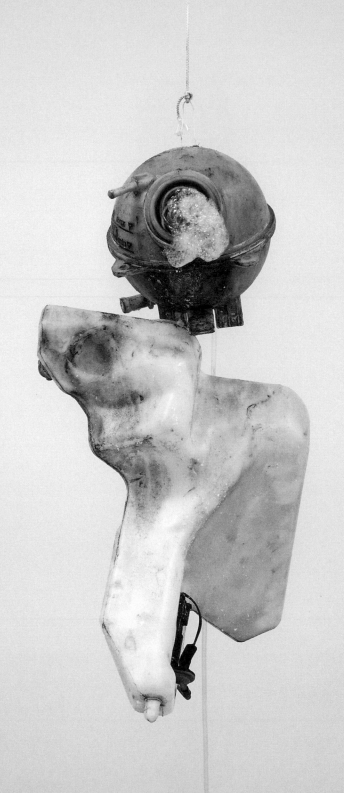

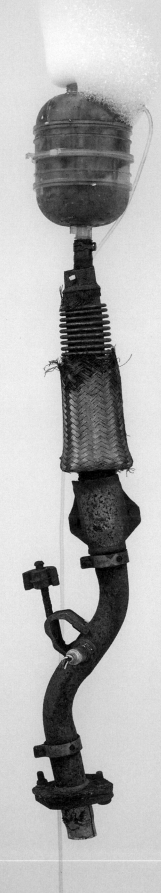

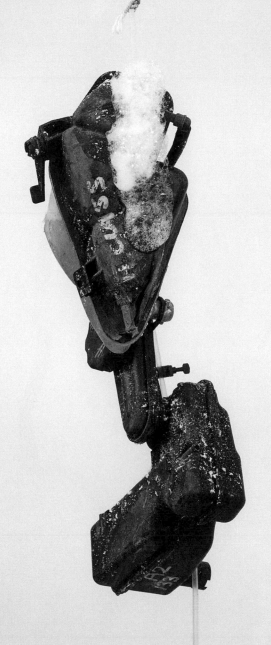

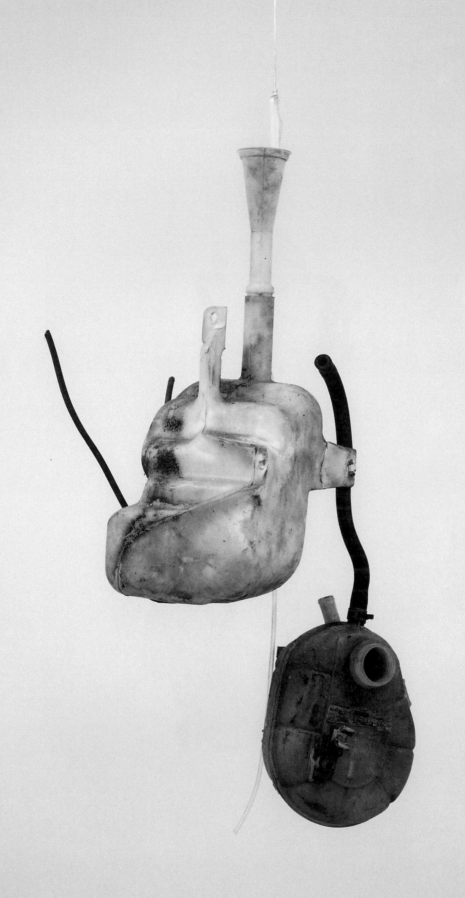

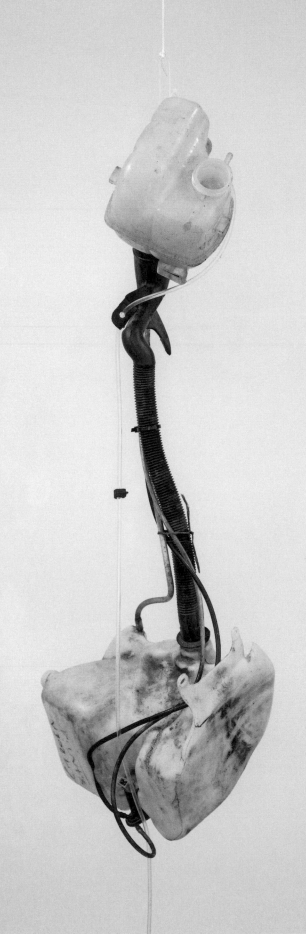

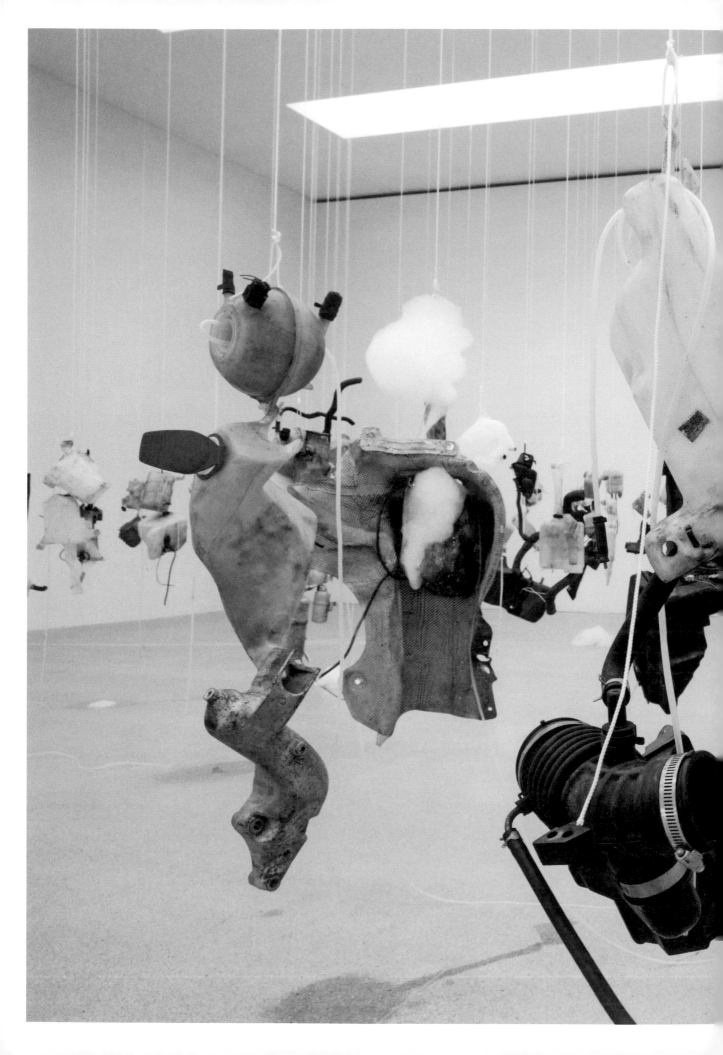

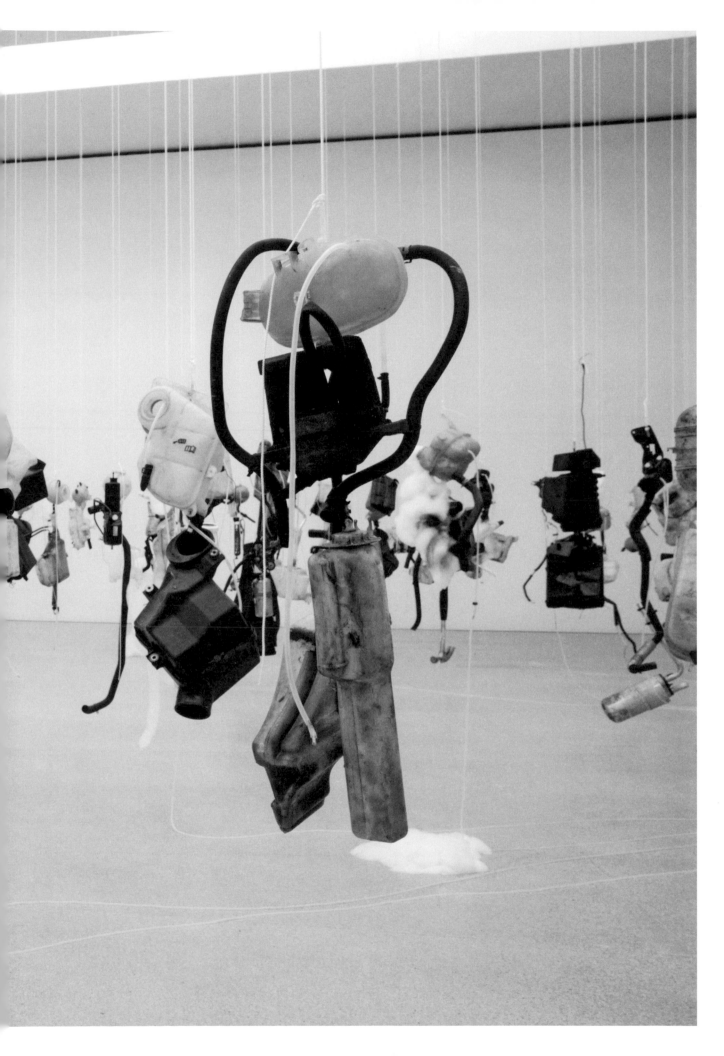

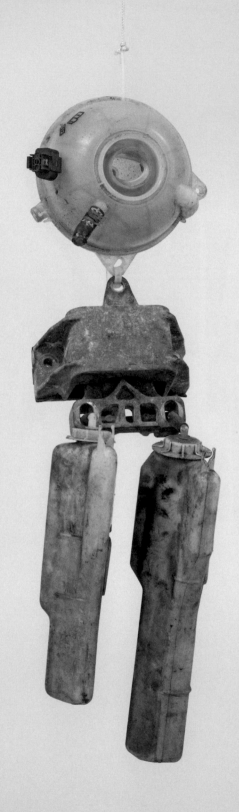

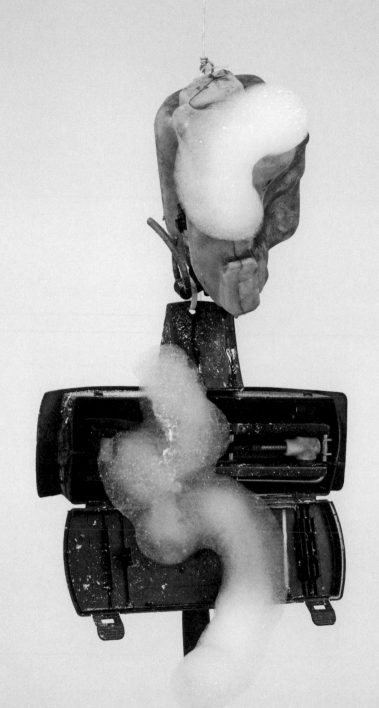

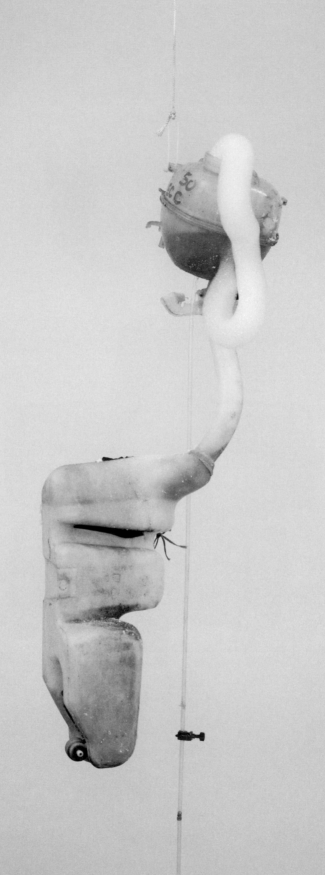

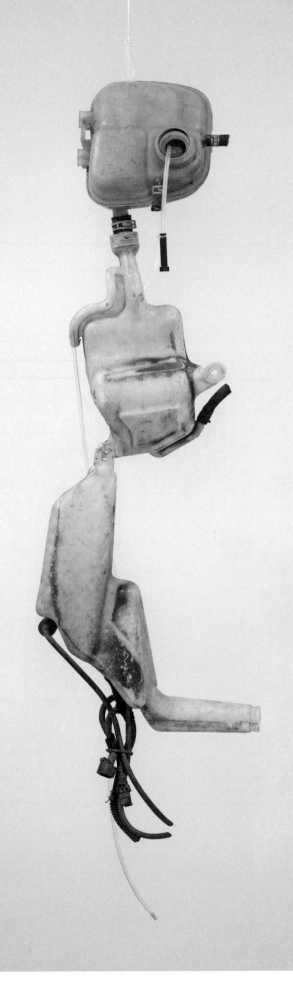

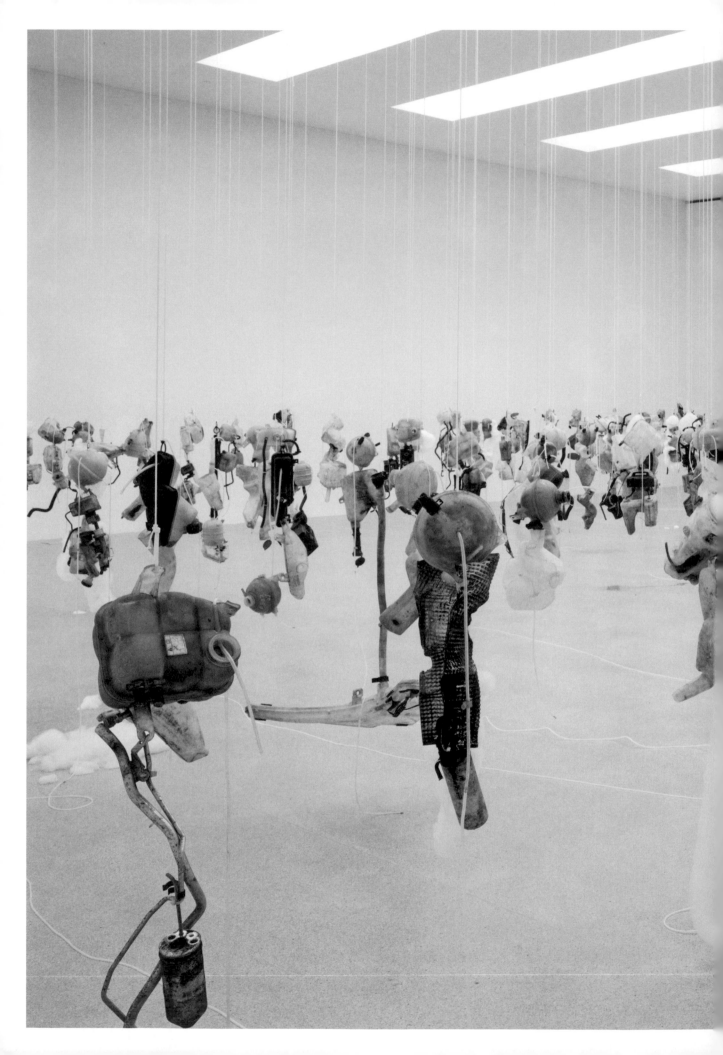

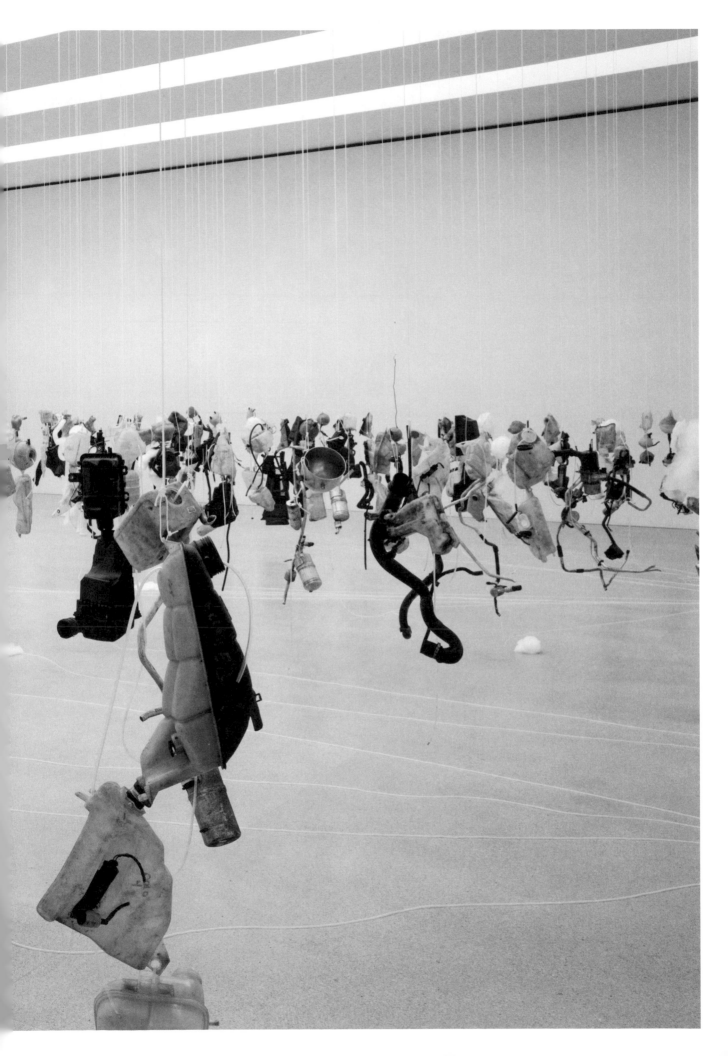

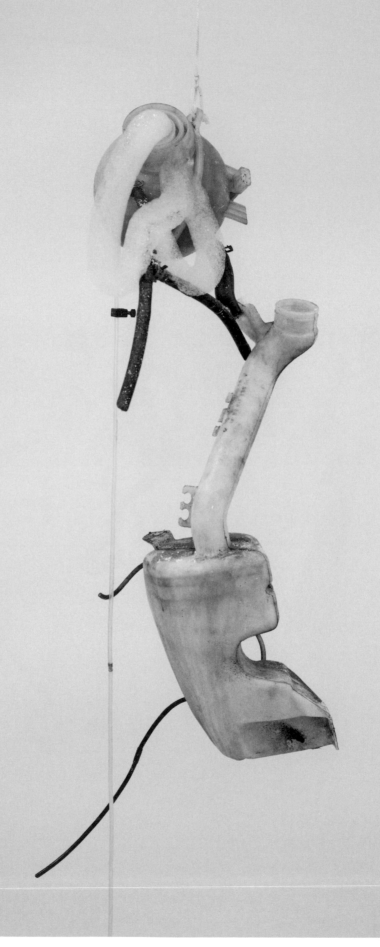

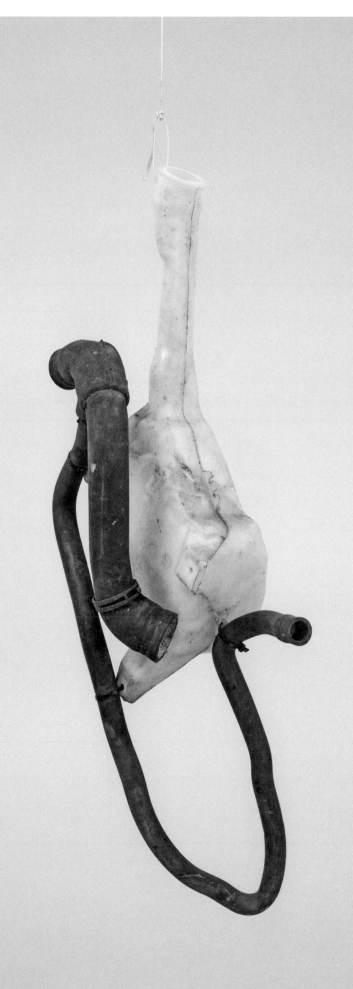

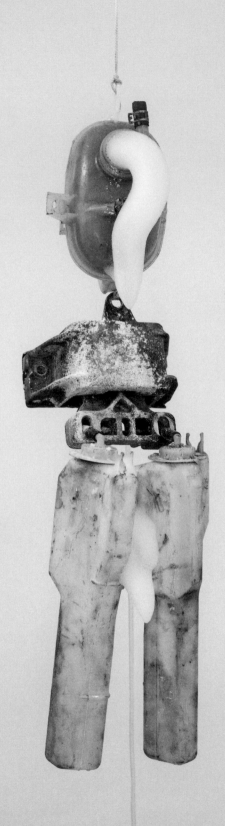

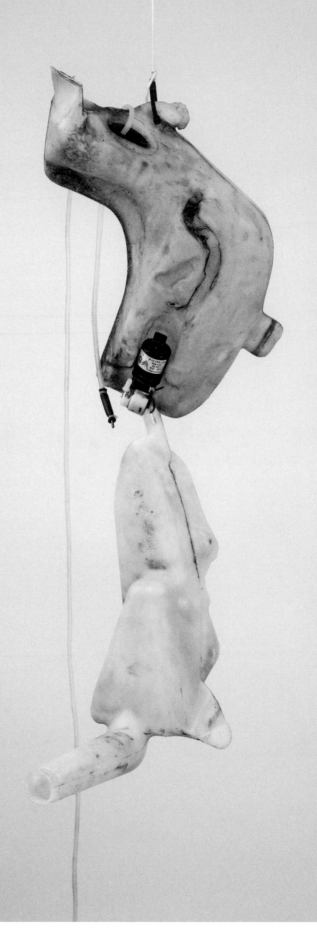

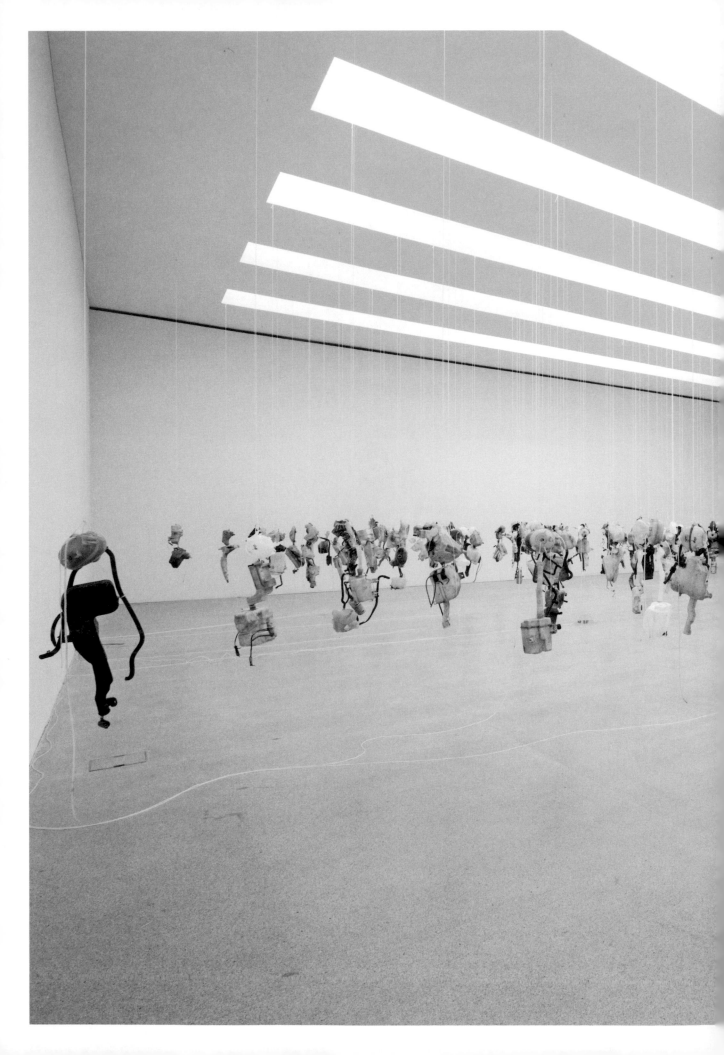

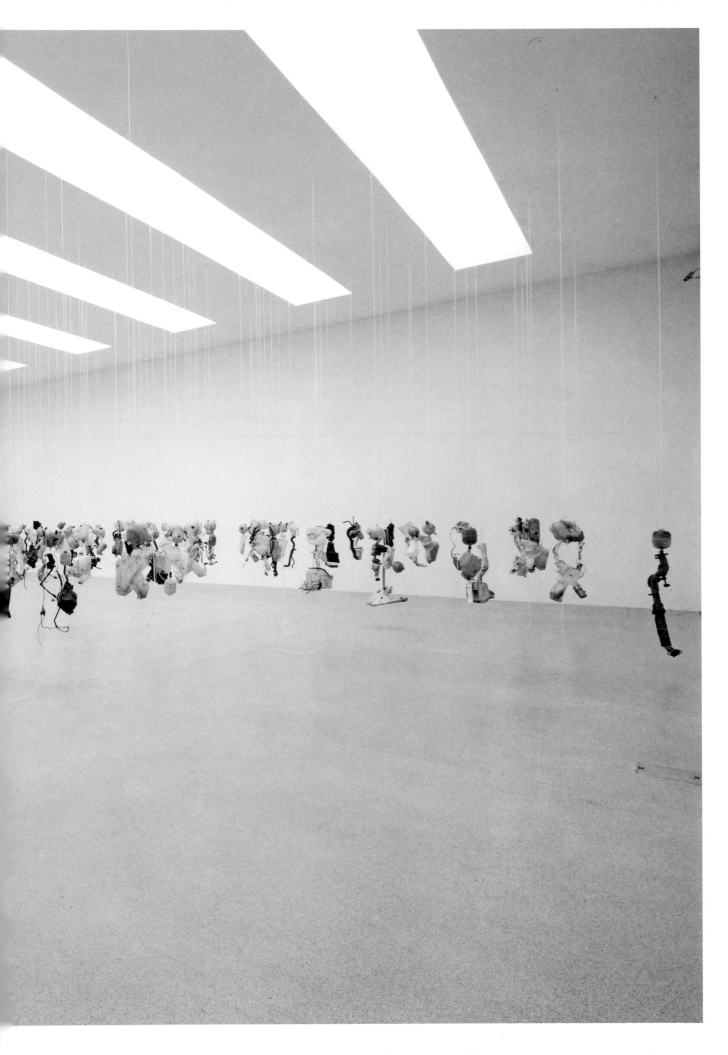

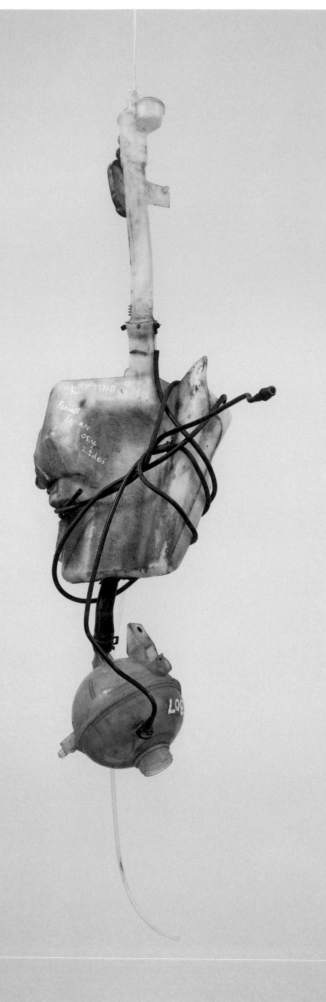

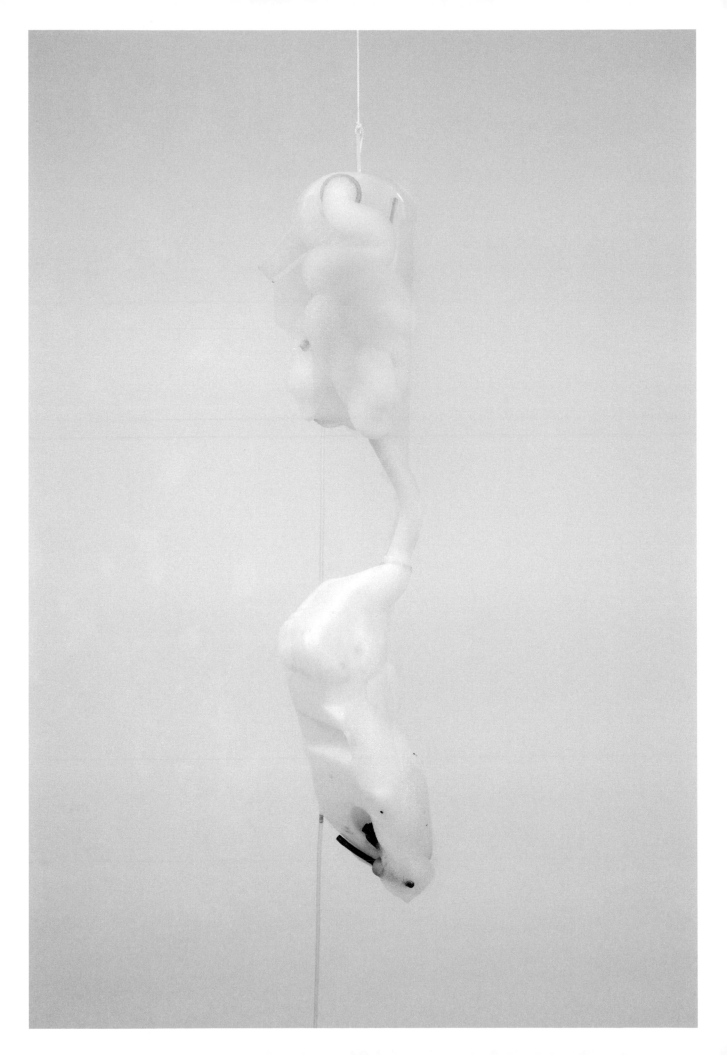

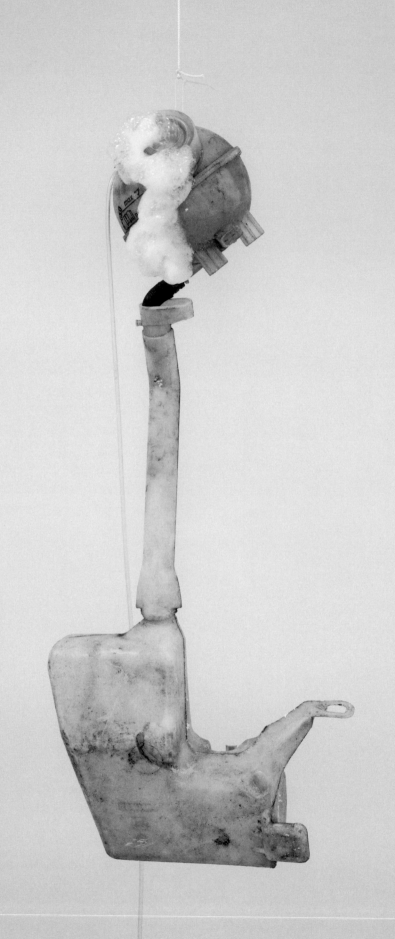

LIST OF WORKS

P.17, 29, 74–77
Untitled, 2014
Extended table, table cloth, youth
Dimensions variable
Courtesy the artist and
Corvi-Mora Gallery, London

P. 6, 19, 58–59, 69–70
Untitled, 2005–2010
Bench, fire, youth
Dimensions variable
Courtesy the artist and
Corvi-Mora Gallery, London

P.18, 69–70
Untitled, 2013
Plasma screens, youth
190 × 98 × 98 cm
Courtesy the artist and
Corvi-Mora Gallery, London

P.5, 20–21, 28, 60–62
Untitled, 2013
Jet engine, fire, anti-depressants, youth
190 × 98 × 98 cm
Courtesy the artist and
Corvi-Mora Gallery, London

P.22, 23, 71–73
Untitled, 2012
Stainless steel tables, fire, youth
250 × 100 × 100, 120 × 100 × 100 cm
Courtesy the artist and
Corvi-Mora Gallery, London

P.12, 24, 63–65
Untitled, 2012
London public bench, fire, youth
Dimensions variable
Courtesy the artist and
Corvi-Mora Gallery, London

p.24
Untitled, 2014
Printed photo image (2 photographs)
Courtesy the artist and
Corvi-Mora Gallery, London
P.25– 27, 66–67

Untitled, 2014
Stainless steel, youth
Dimensions variable
Courtesy the artist and
Corvi-Mora Gallery, London

P. 3, 30
Untitled, 2014 (2 works)
Plastic, foam, car seat
Dimensions variable
Courtesy the artist and
Corvi-Mora Gallery, London

P.31
Untitled, 2014
Resin, brain matter
144 × 32 × 7 cm
Courtesy the artist and
Corvi-Mora Gallery, London

P.32, 57, 78–80
Untitled, 2014
Speaker, digital device, Radio 4 pro-
gramme, cables, rubber, brain matter
Dimensions variable
Courtesy the artist and
Corvi-Mora Gallery, London

P.14, 32, 57
Untitled, 2012
Adapted freezer, youth
88 × 44 × 56 cm
Courtesy the artist and
Corvi-Mora Gallery, London

P. 1–2, 4, 7–8, 11, 13, 105–126
Untitled, 2014
Found plastics, compressor, foam
Dimensions variable, ca. 200 units
Courtesy the artist and
Corvi-Mora Gallery, London

COLOPHON

This publication appears on the occasion of the exhibition «Roger Hiorns» at the Kunsthaus CentrePasquArt Biel from 1 February to 5 April 2015 and at Galerie Rudolfinum, Prague from 28 May to 9 August 2015.

EXHIBITION

CentrePasquArt
Curator
Felicity Lunn, Director CentrePasquArt
Assistant
Damian Jurt
Technician
Paolo Merico

CentrePasquArt
Kunsthaus Centre d'art
Seevorstadt 71–73 Faubourg du Lac
CH-2502 Biel Bienne
T + 41 32 322 55 86
F + 41 32 322 61 81
www.pasquart.ch/info@pasquart.ch

The CentrePasquArt is supported by the City of Biel, the Canton of Bern and the Regional Cultural Conference of Biel.

Galerie Rudolfinum
Curator
David Korecký

Galerie Rudolfinum
Alsovo nabrezi 12, 110 01 Prague 1
www.galerierudolfinum.cz

PUBLICATION

Editor
CentrePasquArt Biel /Bienne
Texts
JJ Charlesworth, David Korecký, Felicity Lunn
Proof-reading
Uta Hoffmann
Graphic Design
Studio Felix Salut & Rudy Guedj

Typeface
Antique Old Style (www.lineto.com)
Printing/Binding
Benedict Press, Germany
Edition
1100
Photo credits
Jon Naiman/Farzad Owrang (1, 2, 4, 7, 8–10, 11, 13, 105–109, 112–115, 118–121, 124–126)/Gert Jan van Rooij (P. 5, 6, 12, 14)

Publisher
Verlag für moderne Kunst
ISBN: 978-3-86984-550-0
© 2015 Roger Hiorns, the Authors, CentrePasquArt Biel/Bienne, Verlag für moderne Kunst
All rights reserved
Printed in Germany

Bibliographic information published by the Deutsche Nationalbibliothek. The Deutsche Nationalbibliothek lists this publication in the Deutsche Nationalbibliografie; detailed bibliographic data are available on the Internet at http://dnb.dnb.de

Distribution
D, A, EU: LKG, www.lkg-va.de
CH: AVA, www.ava.ch
UK: Cornerhouse Publications, www.cornerhouse.org
USA: D.A.P., www.artbook.com

The artist would like to thank Felicity Lunn, Anastasia, Hal and Tommaso Corvi-Mora.
With kind help from Annet Gelink, Luhring Augustine and Corvi-Mora.

CentrePasquArt Kunsthaus Centre d'art
GALERIE RUDOLFINUM